The DK Art School

WATERCOLOR
STILL LIFE

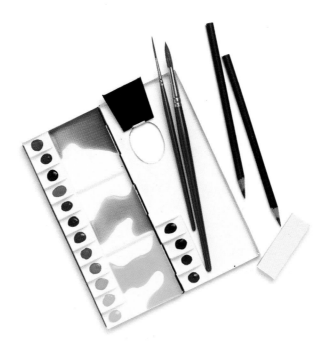

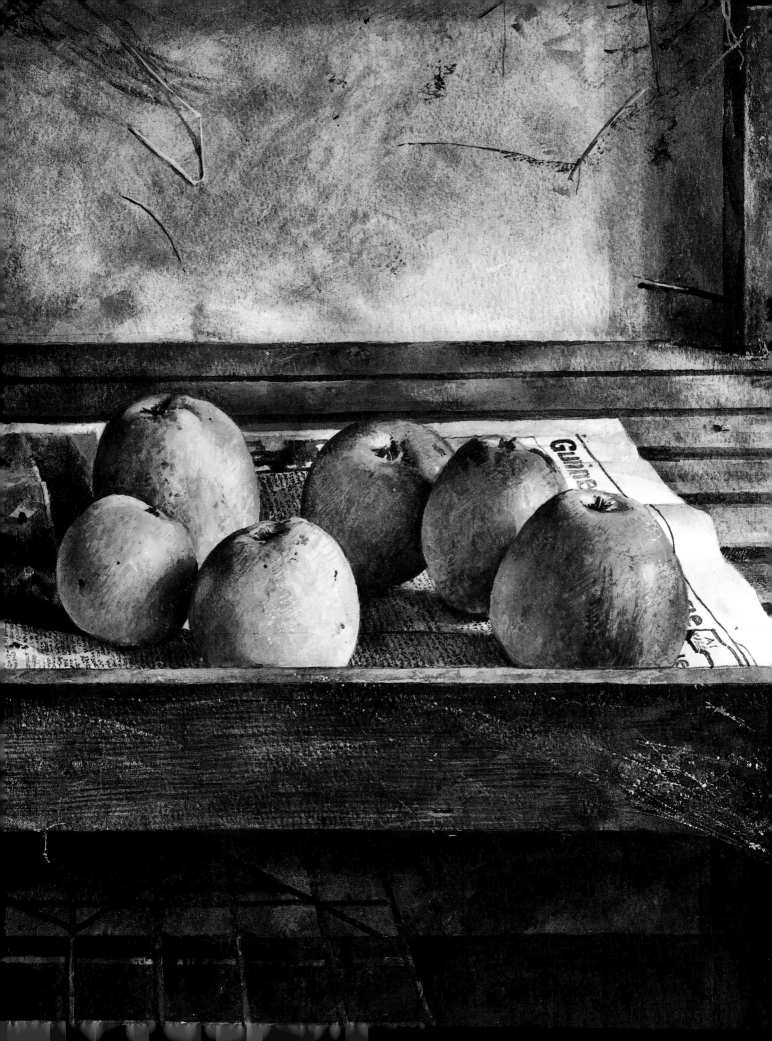

The DK Art School

WATERCOLOR
STILL LIFE

ELIZABETH JANE LLOYD

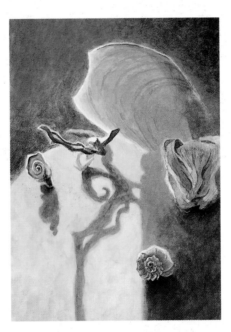

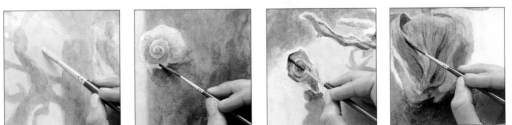

DORLING KINDERSLEY
LONDON • NEW YORK • STUTTGART
IN ASSOCIATION WITH THE ROYAL ACADEMY OF ARTS

A DORLING KINDERSLEY BOOK

Project editor Jane Mason
Art editor Stefan Morris
Designer Dawn Terrey
Assistant editor Margaret Chang
Series editor Emma Foa
US editors Laaren Brown, Mary Ann Lynch
Managing editor Sean Moore
Managing art editor Toni Kay
DTP designer Zirrinia Austin
Production controller Helen Creeke
Photography Andy Crawford, Steve Gorton, Tim Ridley

First American Edition, 1994
2 4 6 8 10 9 7 5 3 1

Published in the United States by
Dorling Kindersley, Inc., 95 Madison Avenue
New York, New York 10016

Library of Congress Cataloging-in-Publication Data
Lloyd, Elizabeth Jane.
 Watercolor still life / Elizabeth Jane Lloyd -- Ist American ed.
 p. cm. -- (The DK art school)
 Includes index.
 ISBN 1-56458-490-9
 1. Still life painting--Technique. 2. Watercolor painting--Technique.
 I. Title. II. Series
ND2290.L58 1994
751.42'2435--dc20 93-47008
 CIP

Color reproduction by Colourscan in Singapore
Printed and bound in Italy by Graphicom

CONTENTS

INTRODUCTION

STILL LIFE PAINTING conjures up images of luscious displays of fruit and flowers or the beautiful arrangements of objects. As a genre, still life evolved from the detailed studies of nature in the sixteenth century to today's more personal approach and wide diversity of subject matter. Watercolor has gradually established itself as the natural medium for painting still lifes because of its purity of hues and its immediacy – it is ideal for capturing color and form quickly.

The development of still lifes

The painting of inanimate objects came about around the seventeenth century, when art patrons wished to be portrayed with symbols of their material wealth. Portraits would include sumptuous displays of food and prized possessions. This form of painting found favor with the wealthy merchants in the Netherlands. Indeed, the term "still life" came from the Dutch *still-leven* meaning motionless (*still*) and nature (*leven*). Artists such as J. Brueghel (*1568-1625*), Rubens (*1577-1640*), and Rembrandt (*1606-69*) produced great works of art in oils in this genre. It was the lesser-known artist Giovanna Garzoni (*1600-1670*) who painted still life in tempera, a water-soluble medium not unlike watercolor. She was, however, way ahead of her time. It was not until the eighteenth century that still life gained a wide popularity in Europe with the spread of the doctrine "Art for Art's sake." Artists started shifting away from formal portraits and religious studies to a more individual approach. This liberal attitude allowed such painters as Jean-Baptiste-Siméon Chardin (*1699-1779*) to depict, with great sensitivity, everyday objects such as kitchen utensils, fruit, and game.

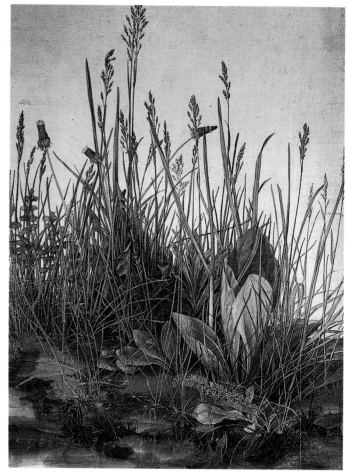

Albrecht Dürer, *The Great Piece of Turf*, 1503
In this exquisite study of wild grass, Dürer shows us that beauty can be found in even the most humble of subjects.

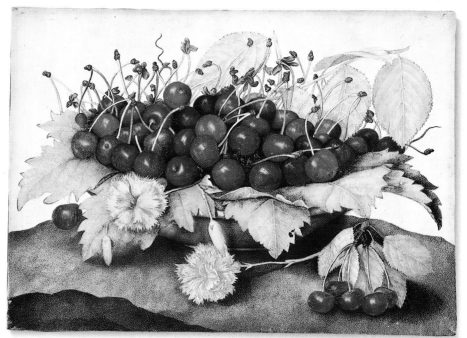

Giovanna Garzoni, *Still Life with a Bowl of Cherries*, c.1650
Garzoni's study of a bowl of cherries is executed in egg tempera on parchment. The paint used was water-soluble, and the addition of egg yolk to the pigment created a stronger medium. The composition is simple without being static. The cherry stems appear to gyrate in a sensuous dance conveying a tantalizing sense of joy and lightheartedness. The sparkling red ripe cherries spill over onto the delicate cool white and pink carnations to produce a striking contrast of form and texture.

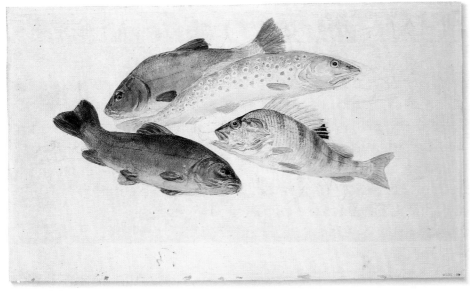

Modern still lifes

In the nineteenth century the course of painting altered radically with artists such as Edouard Manet (*1832-83*), Vincent van Gogh (*1853-90*), and Paul Cézanne (*1839-1906*), whose still lifes rank among the finest works of any kind. Cézanne, who painted in both oils and watercolor, is considered the master of modern still life painting. His still lifes present to the viewer not an imitation of nature but a re-creation of it, revealing to us the beauty of colors and forms; making us see as though for the first time the most ordinary objects such as apples or a jug. In contrast to the sensuous appeal of the nineteenth-century paintings, the twentieth-century artists such as Pablo Picasso (*1881-1973*), Georges Braque (*1882-1963*), and Juan Gris (*1887-1927*) embarked on a totally different approach to the subject. They were concerned with representing objects in two-dimensional geometrical shapes devoid of emotion or empathy, asserting a conceptual rather than a perceived realism. Some other notable modern watercolor still life painters were Emil Nolde (*1867-1956*), Raoul Dufy (*1877-1953*), and Oskar Kokoschka (*1886-1980*). But whatever the style of an individual artist, a good still life should always convey to the viewer a purity of vision that is exciting and inspiring, whether it be of an arranged subject or one painted *in situ,* as in the paintings of the American artist Andrew Wyeth (*b. 1917*), whose still lifes of stark rustic objects kindle a feeling of poignancy and timelessness.

J.M.W. Turner,
Study of Four Fish,
***c.*1822-24**
Turner has positioned the fish carefully so that they appear to be leaping and moving together. The fine texture of their flesh is described vividly.

Paul Cézanne,
Still Life with
***a Jug,* 1892-93**
The interest of this study lies in the rhythms of the rounded forms. The objects were placed so that they created a fine visual balance.

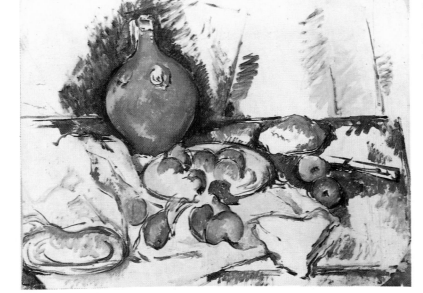

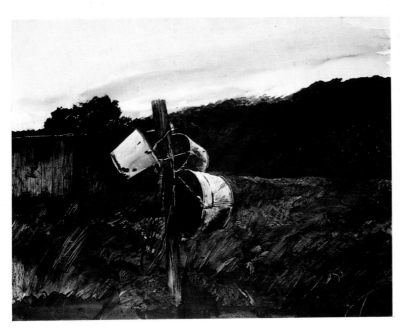

Andrew Wyeth, *Bucket Post,* 1953
Wyeth made watercolor sketches on his travels of scenes and objects that interested him. The beautifully rendered sketches made in his famous notebooks were worked up into finished paintings at a later time in his studio. In this instance, Wyeth was perhaps struck by the gleaming whiteness of the buckets against the dark hedge.

PAINTS AND PIGMENTS

WATERCOLOR PAINTS ARE MADE from a variety of sources and come in a vast range of colors. Many are now chemically made, but some pigments are still derived from traditional substances such as minerals and plants. Paints are essentially made up of pigment, a water-soluble binding material, and a substance that increases their flexibility. The first watercolors were not lightfast, but since the eighteenth century, the addition of chemical dyes has greatly increased the durability of the colors.

Madder root
From Egyptian times until the nineteenth century, madder plants were highly prized as the source of the red Alizarin dye. The plants' roots (*above*) were pounded and simmered to extract the dye, which was then turned into pigment.

Terre Verte
First found in Cyprus and France, this blue-green iron-oxide pigment (*right*), often known as green earth, was used by artists in Roman times. It is a natural earth pigment and produces a range of color from blue-gray to olive green.

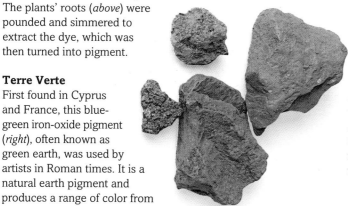

Cochineal beetles
Dried beetles are the source of Carmine, a color that fades quickly. The beetles are collected in Peru and the Canary Islands, then dried and crushed to make the red dye. Carmine was used in Europe in the mid-sixteenth century and is still in use today in oil and watercolor paints.

Raw Sienna
The yellow-brown pigment made from iron-rich Italian clay (*left*) became popular in England after watercolor artists first toured Europe. It was one of the earth pigments used in Italian frescoes from the thirteenth century. Its grainy color is particularly suitable for landscape painting.

LIGHTFASTNESS

As watercolor is susceptible to damage on exposure to light, it is vital to buy paints with a high lightfastness rating. Lightfastness or durability of color is measured in the US by the ASTM (American Standard Test Measure) – permanent colors rate 1 or 2; and in the UK by the Blue Wool Scale (the most permanent colors rate 7 or 8).

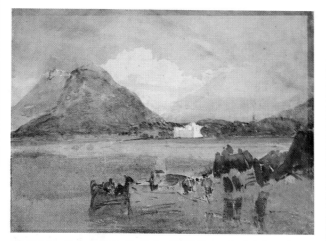

The painting above, Inverary Castle *by J.M.W. Turner, has faded over the years. You can discern colors that are closer to the original ones by looking at the outer edge of the work, where the paints were protected from some of the harmful effects of light by the frame.*

Lapis lazuli
This semiprecious stone produced the most highly prized of traditional pigments, Ultramarine. The ground mineral, mixed into a resinous paste with oil and gum, was kneaded in water. The color that was released could then be turned into pigment. In early Italian painting, Ultramarine was considered so precious that it was reserved for the most significant figures, such as Christ and the Virgin Mary.

The manufacture of paints

Paint is made by mixing the raw pigment with gum arabic, a natural sap taken from the acacia tree. Glycerin, a syrupy liquid that is used in small amounts to aid adhesion and flexibility, is also added to the paint mixture. In the past, honey was often used for this purpose. The paste is ground on granite triple roll mills and dried in large round cakes before being forced through a die and extruded into sticks or, alternatively, put directly into tubes. The sticks of color are then cut into whole or half-pan sizes before being wrapped.

Slabs of dry color

Scarlet Lake

Cadmium Yellow

Pan colors

Every pigment has particular requirements in order to produce a stable and workable color. With pan colors, the manufacturer has to ensure that the paint does not dry out in the box but also that it does not absorb too much moisture and become soft. The difference between artists' quality colors and cheaper brands is substantial.

Pan colors

Cobalt Blue

Tube colors

Differences between pan and tube watercolors vary from pigment to pigment. The main difference, however, is that there is more glycerin in the tube colors, and this makes them a little more soluble than the pans. This characteristic makes tubes the better option when creating large areas of wash.

Viridian

Gouache paints

Gouache, or body color, is a water-soluble paint characterized by its opacity rather than by the transparent effects usually associated with watercolor. It can be used to create highlights in a traditional watercolor painting, or to provide a uniformly even tone.

Half-pan color

The effect on paper

Traditional watercolor (*right*) is a translucent painting medium. Its effect relies on the fact that rays of light penetrate the watercolor paper and are reflected back to the viewer. In contrast, gouache or body color (*below*) provides a matte, uniformly even tone particularly suitable for overlaying color or for use on toned or colored paper.

Transparent watercolor

Gouache paints

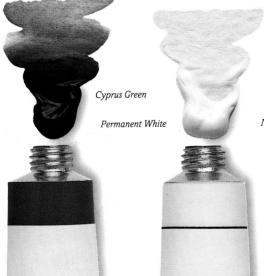

Cyprus Green

Permanent White

Naples Yellow

Opaque gouache

CHOOSING YOUR PALETTE

Once you have learned how to mix colors (pp.12-13), a range of reds, blues, and yellows should provide you with nearly every color you need, although you will probably want some greens and an ochre as well. Always try to arrange your paints in the same sequence on your palette. If you keep to this arrangement of colors, you will find yourself turning to the right paints instinctively, just as a practiced pianist finds the right keys of a piano.

Ready to begin
There is a vast range of palettes to choose from: simple plastic palettes have large pools for mixing colors; metal paint boxes, like the one on the right, have folding panels on which to mix your paint.

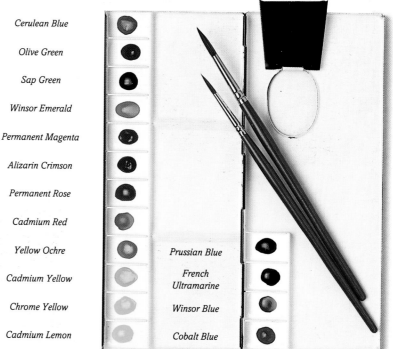

Cerulean Blue

Olive Green

Sap Green

Winsor Emerald

Permanent Magenta

Alizarin Crimson

Permanent Rose

Cadmium Red

Yellow Ochre

Cadmium Yellow

Chrome Yellow

Cadmium Lemon

Prussian Blue

French Ultramarine

Winsor Blue

Cobalt Blue

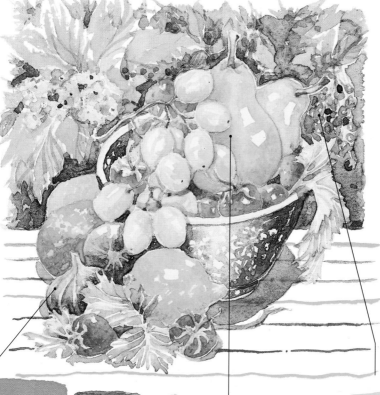

Cadmium Red is an orange-red pigment with a strong tinting strength.

Cadmium Yellow is a dense golden yellow with a hint of orange.

French Ultramarine is a pure durable blue with violet undertones.

Cadmium Red and French Ultramarine combine to make a sultry purple.

Rich dark purples are perfect for describing the softly shining skin of the voluptuous ripe figs.

Primary concerns
The three primaries, mixed in varying combinations and amounts, produce "secondary" colors, i.e., orange, green, and violet. Try reds with yellows, yellows with blues, and blues with reds to see what can be achieved. The still life (*left*) was painted with Cadmium Yellow, Cadmium Red, and French Ultramarine only.

French Ultramarine and Cadmium Yellow, when mixed together in varying proportions, produce many greens.

Golden green grapes and the blue-green of the background leaves are produced using the same elements.

Cadmium Yellow mixed with Cadmium Red creates a vibrant orange.

Orange is used in an intense mix for brilliant color, and as a muted golden hue for the pear.

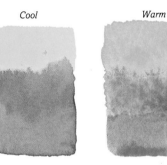

Warm composition

Fiery reds, bright oranges, and golden yellows depict the carrots, peppers, orange, and tomato (*right*). These colors are essentially warm – i.e. biased toward red – but the slightly blue-tinged scarlet of the pepper appears as a "cooler" red (biased toward blue) next to the hotter orange. Objects painted in warm colors appear to advance on the paper. Where so many warm colors are seen together, the "coolest" warm color will seem to recede.

Primary bias

Warm primaries (biased toward red) or cool ones (biased toward blue) make secondaries biased in the same way.

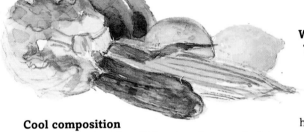

Cool *Warm* *Cool* *Cool*

Cool *Cool* *Warm* *Warm*

Cool composition

Lemon yellows and cool blue-tinged greens depict the pepper, cucumber, lettuce, zucchini, lime, and lemon seen in the sketch above. Cool colors recede into the distance, but, where so many cool colors are seen together (as here) the slightly warmer yellow-green of the large zucchini will appear to come forward from the blue-green of the pepper.

Warm and cool combined

Together, warm and cool colors create light, depth, and space in a painting; warm colors advance, and cooler hues recede. The golden shades of the bread and cheese stand forward, while the cold flat green of the bottle and the steely claret red of the wine appear to move back in space.

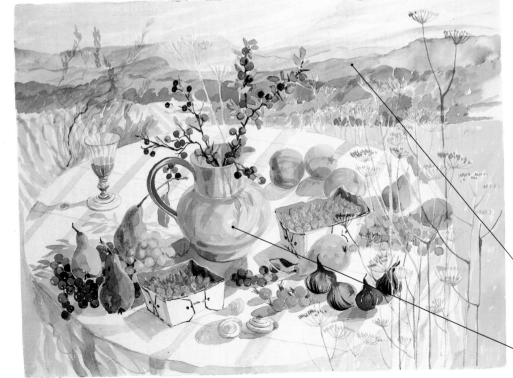

Outdoor still life

Here a table arranged with earthenware and food portrayed in homey warm colors stands out before the cool mauve mountains in the distance. However, when the same cool blues and mauves are repeated in the fruit and shadows, they appear as warm colors. Colors react to one another and will change depending upon the context of use.

The distant hills are painted in cool blues, grays, and violets – colors derived from some of the cooler primaries such as Cobalt Blue and French Ultramarine, mixed with Alizarin Crimson.

The golden earthenware, like the warmly toned fruit and flowers, are painted in colors derived from Yellow Ochre, Cadmium Orange, and Burnt Sienna, giving a great warmth and vitality to the still life.

11

MIXING COLORS

A PALETTE OF PRIMARIES, with perhaps a green and an earth pigment, yields an extraordinarily wide range of colors. Violets, oranges, and greens can be made from a few pigments. Emerald has been included in the selection below because it is based on a dye and cannot be mixed. Record all of the colors you have produced in a sketchbook to remind you of the myriad of possible variations. As a separate exercise, try varying the percentage of each color used.

The strength of this simple painting of a lily lies in its use of the complementary colors, red and green.

Multiplying by color
Paint stripes of your palette colors. When dry, paint over them in a crisscross pattern.

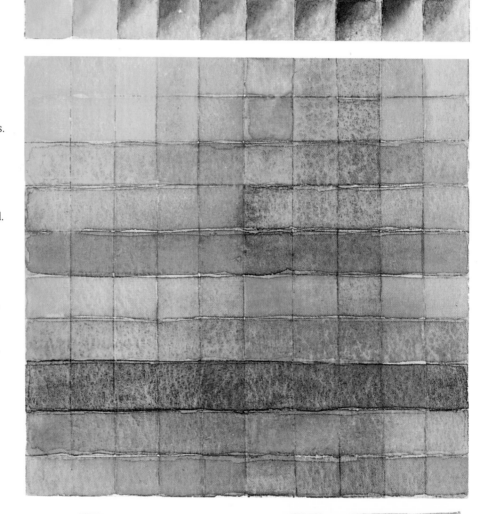

Cadmium Lemon
A cool blue-toned yellow.

Cadmium Yellow
A golden yellow with a red bias.

Yellow Ochre
An opaque orange-yellow.

Cadmium Red
A rich, semi-opaque yellow-red.

Permanent Rose
A clean transparent blue-red.

Winsor Emerald
Clear vivid dye-based pigment.

Cerulean Blue
A semi-transparent blue-green.

French Ultramarine
A pure durable warm blue.

Prussian Blue
A traditional transparent blue.

Raw Umber
A transparent greenish brown.

How colors work together
Position a selection of fruit in a pleasing configuration. Paint them in bright colors and block in a contrasting foreground and background. In the first sketch, golden yellow and rich red apples and cherries appear to be closer to us than the cooler blue and green grounds. In the second study, a warm yellow ground dominates the green apples, but the bright red advances even on a strong yellow ground. As you paint, you learn that every color, strong or subtle, influences its neighbors and changes depending upon context.

Mixing greens

Blue pigments are relatively powerful, so a green should always be mixed by adding small touches of blue to yellow. Try combining a range of warm and cool blues with the warm and cool yellows in your palette. Here you see the subtle gradations of green you can achieve by mixing a selection of blues with various yellows. Simply paint bands of yellow across relatively dilute bands of blue. When you have made a wide range of greens, and experimented with some complementary colors, set up your own composition in green, like the one shown below, and then begin to paint it, keeping the swatches of greens beside you as you work.

Cadmium Lemon

Chrome Yellow

Cadmium Yellow

Cadmium Yellow Deep

Indian Yellow

Naples Yellow

Cobalt Blue *French Ultramarine* *Permanent Blue* *Winsor Blue* *Prussian Blue* *Cerulean Blue*

Still life in green

Try collecting a variety of objects that are shades of green, and then create your own still life composition from them.

How green is your palette

Yellows and blues have been combined to create the greens in this still life. You can choose the precise color you need from the swatches you created in the exercise above. Emerald, a green that cannot be created by mixing primaries, has also been used to paint the table top. Within the painting, warm and cool greens operate together, moving objects forward or back on the picture plane. You can see how the golden green of the apples clearly advances from a cool green background.

Violet shadows form the perfect complement to the strong yellow of the gilt-patterned plate.

Pale highlights shine upon the cool peacock blue-green of the bowl of the wine goblet.

The leaf green of the plate is bright in the brilliant light directed at the still life composition. A green like this can be made with a strong yellow such as Indian Yellow or Cadmium Yellow Deep and just a touch of Prussian or Cerulean Blue.

The bright green of the patterned cloth comes forward in space. Where the cloth falls in deep folds upon an Emerald ground, the soft shadows within the folds and the shadow of the solitary golden apple are painted in cool blue-greens.

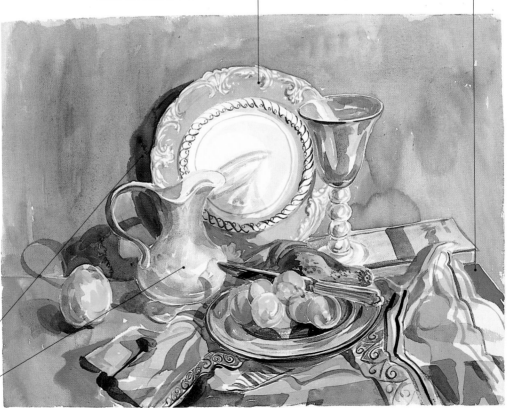

Elizabeth Jane Lloyd

13

GALLERY OF COLORISTS

A PAINTING'S USE OF COLOR connects the onlooker to the poetic imagination and creativity of the artist. Color is one way in which the artist conveys emotion and reveals his own interior feelings. Color can suggest mood and depth but, like music, it also acts on the senses to excite, relax, or move the viewer. Color can be vibrant and high-key, or muted and low-key, or subtle combinations of the two. Stunning effects can be achieved with bold hues and subtle atmosphere can be created with soft cool hues. The artist's choice of colors signifies the perceived world. The painting, even momentarily, provokes an immediate response – a gasp or a sigh – and remains as a vibrant memory in which color resonates.

William Hough, *Apples and Plums*, 1869
The technical proficiency of Victorian watercolorists is demonstrated well here. The paint is dexterously applied to suggest the fine bloom of the plums; their soft blues and purples shine softly against the broken texture of the ground on which they lie. Yellow and orange apples create a change in the picture plane: their warmer colors stand out against the muted colors of the foreground. The whole composition has been painted with infinite care using tiny, meticulous brushstrokes.

Hercule Brabazon, *Red, White, and Blue*, c.1885
Brabazon is best known for his sketches of his travels executed on Turner Gray paper using white body color and watercolor, with a transparent glaze over the white body color. Here, using the same method, Brabazon has worked on a toned ground. Pure colors laid on top of the white body color shine clearly as glowing highlights.

For the flowers Brabazon has used Chinese White overlaid with red and blue watercolor to glaze the petals. The red, blue, and white blooms resonate against the deep blues and browns that create tone in the subdued background.

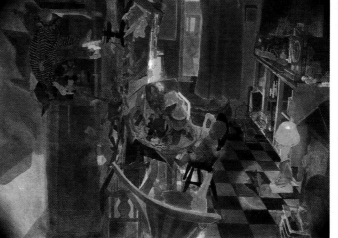

This subtle balance of complicated forms draws the eye back and forth across the room. The areas of light – the lamp and the open doorway – form the main focal points against the muted colors of the interior. The painting is divided into thirds; balance is created instinctively within the intimate space.

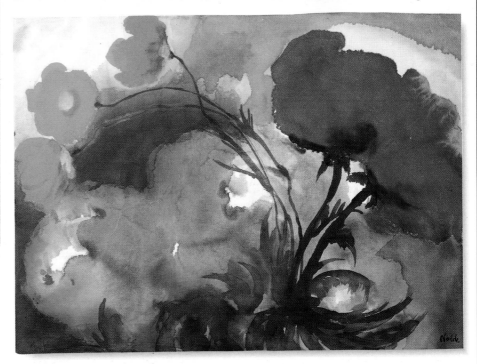

Emil Nolde, *Red and Orange Poppies, c.*1900
Nolde is an expert in using color as a poetic expression. Central mauves and blues create an amazing depth of space, while the bloodred poppies burn against the ground, and the exotic orange petals vibrate against the mauves.

Geraldine Girvan, *Embroidered Cloth*
The vibrant colors of this composition are cleverly felt and placed. Blue patterns hold the yellow backdrop in its spatial position, away from the dominant tablecloth. The vermilion of the cloth is emphasized by the glowing oranges and apples.

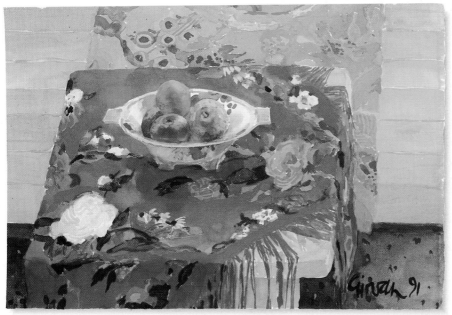

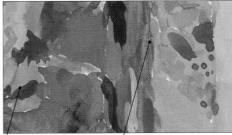

Dark green leaves become almost black where the cloth falls over the edges of the table, dropping away from the picture plane.

The artist makes fine use of complementary colors on the far wall, where soft blue-mauves throw the shades of burning orange forward.

BRUSHES AND BRUSHSTROKES

IF PAINTING IS A LANGUAGE, then brushstrokes are the subtle nuances of tone and inflection that give it meaning. A good brush is an essential tool, but in order to make the very best use of it, you will need to practice daily to perfect your brushstrokes. In Japan, artists train for at least three years in the art of making brushstrokes. Students practice making fluid, graceful marks on paper, aiming for the ideal stroke; only when they have achieved absolute perfection and control are they allowed to attempt a simple image such as a stem of bamboo. In the West, brushes are used in various ways, depending on the style or approach of the artist. They can be used vigorously and expressively to create brushstrokes of great energy and immediacy, or softly and subtly, laying down colors to produce delicate tonal effects.

On location
A commercially made or homemade brush holder will provide excellent protection for your brushes when you are traveling or working on location.

Analyzing your brushstrokes
By practicing brushstroke techniques you will grow in confidence and skill. Try drawing with a large brush overlaying strokes in one direction. Touch the paper delicately, then allow the brush to open out to full capacity.

The full body of a large round brush carries a generous amount of pigment. It will open out to make a broad mark, like this full blue stroke, although as you experiment you will find that one large brush fulfills almost every purpose; laying washes, drawing details, or making precise patterns.

Taking a brush well loaded with purple paint, begin with a light brushstroke using only the tip, known as the "toe" of the brush. Then increase the pressure until its full width comes into play.

Fine lines, like this wispy red stroke, can be drawn with the tip of a large sable or sable/synthetic round brush of good quality because the brush always springs back into shape to make a perfect point.

How to hold your brush
Whether standing or sitting, make sure that you are comfortable when you are getting ready to begin painting. Relax your shoulders and let your arms swing freely before taking up your brush. Practice your brushstrokes by making smooth, continuous strokes across the paper before moving on to a simple subject such as cherries *(see facing page)*. You may find it helpful to steady a rounded stroke by using your little finger as a balance.

BRUSH TIPS

● To test the quality of a round soft-hair brush, dampen it and then see if it will form a perfect point.

● Keep your brushes clean, and try to avoid building up deposits of paint in the ferrule since this will splay the brush open and ruin its point.

Flat wash brush
Wash brushes are wide and flat and available in a large range of sizes. They are ideal for toning paper or laying washes because they distribute the paint quickly and evenly.

Musical strokes
This violin has been painted with a great variety of brushstrokes, from the broad golden wash of its body – executed with a flat wash brush – to the fine lines decorating its surface edge – executed with the tip of a small round brush.

No. 6 round
Medium to large round brushes (available up to a vast No. 24) make almost every type of stroke you will require. Manipulate the brush until you know how it responds.

No. 3 round
Small round brushes give excellent control. The smallest, No. 00, is often used by painters who specialize in botanical studies.

Flat brush
Flat brushes come in a range of sizes from ⅛ inch to 1 inch or more. The fine edge of the brush will produce firm, clean lines. Practice making a single brushstroke, turning the brush sideways as you work, and you will create an elegantly graduated mark.

Practice makes perfection
When you are practicing brushstrokes over and over again to get the feel of them, or making very simple sketches to improve your brush movements, you will find that you use a great deal of paper. Because fine watercolor paper is expensive, try using old newspapers or an out-of-date telephone directory until you begin to feel assured and fluent in your strokes.

Japanese brush
Oriental soft-hair brushes are made of deer, goat, rabbit, or wolf hair. Traditionally the brush is held in the fist at an angle of 90° to the paper.

SELECTING PAPER

W E HAVE LOOKED AT PAINTS and brushes and how they will affect the appearance of your paintings, but paper is equally important. Paper comes in a range of weights and surfaces, and can be machine-made or handmade. Machine-made paper is also known as "mold-made." It is important to know what you are buying and how you wish to use it since some types of paper are better suited to certain painting techniques than others. Rough-textured paper, for example, is good if you want a grainy effect because pools of paint collect in the dips of the paper. Smooth paper, on the other hand, is best if you want to lay flat, even washes of color. Heavier papers do not need stretching and will withstand rigorous techniques such as scrubbing out colors or sgraffito. Acidity is another factor you should consider. It is always preferable to use acid-free paper with a neutral pH because this will not yellow or darken excessively with age.

Illuminated manuscript
Before the advent of paper, vellum or calfskin was used as a support for watercolor illustrations.

Texture
Machine-made watercolor paper comes in three standard textures – Rough, HP (Hot-pressed) and NOT (Cold-pressed). Rough paper is coarse-grained; with dips and hollows in the surface. HP paper is fine-grained and good for drawing techniques or for painting fast as paints dry quickly on its smooth surface. NOT – literally "not Hot-pressed" – paper is medium-grained and provides a mildly textured surface to hold the pigment. These categories vary from one manufacturer to another, so look at several types before you decide which you want to buy.

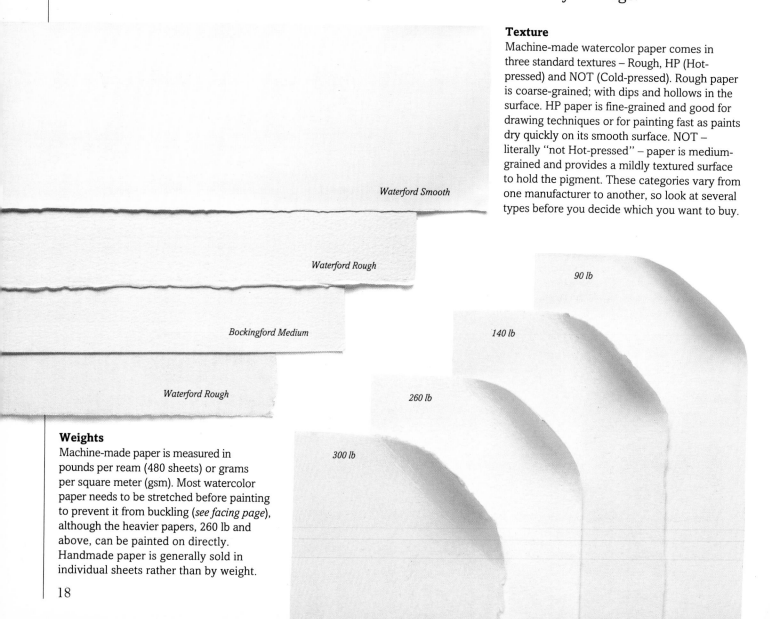

Waterford Smooth

Waterford Rough

Bockingford Medium

Waterford Rough

90 lb

140 lb

260 lb

300 lb

Weights
Machine-made paper is measured in pounds per ream (480 sheets) or grams per square meter (gsm). Most watercolor paper needs to be stretched before painting to prevent it from buckling (*see facing page*), although the heavier papers, 260 lb and above, can be painted on directly. Handmade paper is generally sold in individual sheets rather than by weight.

Handmade paper

Paper is produced by felting together fibers obtained from a variety of plant sources. The examples on the right are made by hand and are relatively heavy, although handmade papers can be as fine as tissue paper. You can recognize this type of paper by its rough or uncut edges, known as deckle edges. Handmade paper can take up to three months to prepare.

Handmade, cotton, Smooth

Handmade, buff gunny, Rough

Handmade, gray-flecked, Rough

Handmade, Rough

Machine-made tinted paper

Machine-made paper

In the West, most artists' papers are now processed from cotton fibers. Machine-made papers are manufactured on a moving belt, and can be bought either by the sheet or by the roll. Considerably cheaper than handmade papers, they are in many cases equally satisfying to use. The main difference is in the surface texture, which tends to be more uniform and even.

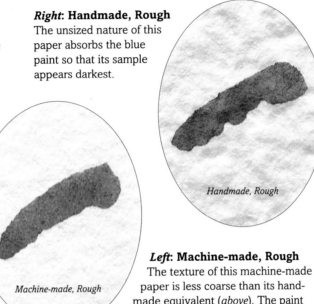

Right: **Handmade, Rough**
The unsized nature of this paper absorbs the blue paint so that its sample appears darkest.

Handmade, Rough

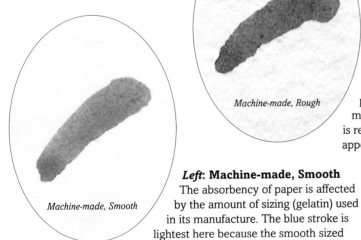

Machine-made, Rough

Left: **Machine-made, Rough**
The texture of this machine-made paper is less coarse than its handmade equivalent (*above*). The paint is readily absorbed by the paper and appears quite dark.

Machine-made, Smooth

Left: **Machine-made, Smooth**
The absorbency of paper is affected by the amount of sizing (gelatin) used in its manufacture. The blue stroke is lightest here because the smooth sized paper has repelled the paint.

Tinted paper

There is a vast range of warm and cool tints of paper available for the watercolor artist. The tone of the paper can be used effectively to provide a backdrop or to create a unifying element in your painting.

STRETCHING PAPER

1 *Wet your sheet of paper thoroughly with cold water for about two minutes to allow the fibers to expand. Do not use hot water, since this might remove the gelatin surface sizing of the paper.*

2 *When your paper is thoroughly wet, put it on the drawing board, smooth it out, and sponge off any excess water. Moisten four strips of gum tape, one for each side of the paper.*

3 *Take the gum tape and stick the paper down firmly around the edges. Now let the paper dry. As the water evaporates, the paper fibers contract, making the paper hard and flat.*

EXPRESSIVE BRUSHWORK

YOU CAN CREATE AN INFINITE variety of brushmarks and patterns with just one brush, and you will rarely need more than two for a painting. Assuming you are using good-quality brushes, you will find that even a large brush is capable of making delicate, controlled lines. Sable brushes are springy and come to a fine point, but sable/synthetic mixes are equally versatile and considerably less expensive. Practice making different strokes with a large brush, varying the amount of paint that you use and the proportion of pigment to water.

Use the tip of the brush to make the finest of lines; press down to use the full breadth of the brush to lay in washes or to block in large areas of color. Try out brush techniques in which you "drag" the paint across the surface to create a textured or "dry brush" effect, perhaps allowing another color to show through the dry brushstroke. Wet the brush and the effect will be quite different – producing large areas of color in broad, watery sweeps.

Kordofan Gum Arabic is the most popular form of gum.

1 ▶ Fish, with their broad areas of color, and lilies, with their delicate markings, make good subjects for this exercise. Draw in your basic shapes and lay a wash of Indigo with a large brush to represent the skin of the mackerel. Use a dilute Golden Ochre for the flesh tones. Allow both the colors to run together to create the underbelly.

2 ▶ Moving to the herring below, add a little gum arabic solution to a wash of Mauve and Indigo and paint along the upper ridge. The gum arabic will make the color seem shinier. Add a further layer of Indigo. Once this has dried, scratch into the paint with the other end of the brush to create the scales.

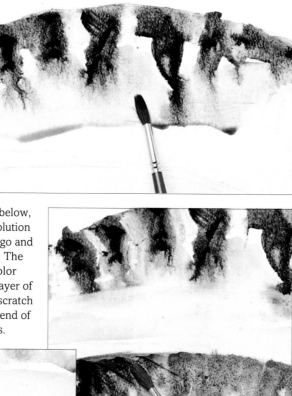

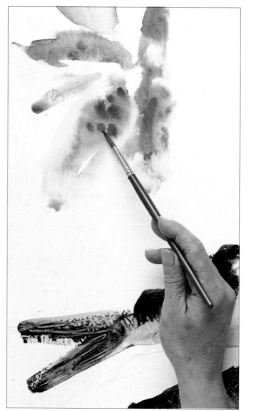

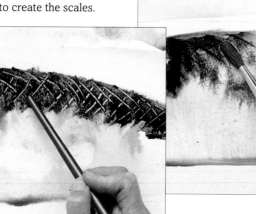

3 ▲ With a large brush, start painting in the leaves with a watery green. Then "paint" the shapes of the lily flowers with clean water to moisten the paper. Before this dries, lay in a dilute wash of Rose Madder. The wash will run to the edges of the shapes you have painted with the water. With a smaller brush, dot in an intense solution of Rose Madder to make the spotted patterns of the petals.

4 ▲ For the darker leaves, take a little Sap Green onto a dry brush and lay the color onto the paper in dry, grainy strokes. Then, with your nail, scratch through the pigment to create white ridges in the dark green stems and leaves.

5 ▶ For the remaining lilies, paint them as before with a large brush dipped in clean water so that areas of the paper are moist. With a smaller brush, apply a Rose Madder wash in loose brushstrokes. The pigment will flow into the moistened area of the paper and bleed outward. Next, flick some drops of pure Rose Madder pigment into the Rose Madder wash using the same small brush. If made on a wet ground, such marks will bleed to create a soft, diffused look.

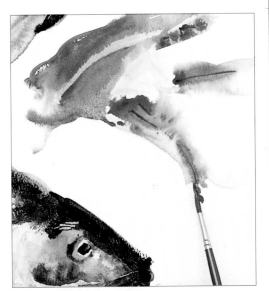

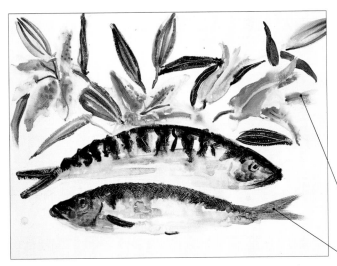

On a white ground
The forms of the fish and flowers are slightly lost on the white ground, but sgraffito effects in the darker areas stand out.

The dots of deep pink were made by loading a brush with pigment and flicking it. The spots have not bled because the underlying paint was dry.

The end of the brush has been used to scratch away the dried pigment in the tail of the fish.

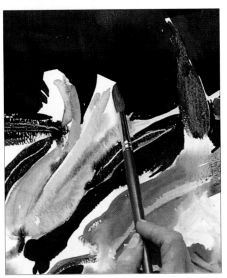

6 ▲ Add a background that will throw the images forward. Use a dense wash of Indigo, applied with a large brush. Fill in the background evenly and quickly, using broad, loose strokes.

Fish and flower design
Very different effects have been achieved in this vibrant painting using just two brushes. The bold washes of color are balanced by delicate lines – some applied with the tip of the brush, some scratched out with the other end of the brush – to create this powerful two-dimensional design.

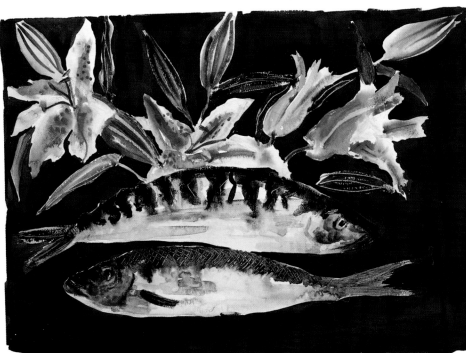

The Indigo wash creates a rich backdrop for this arrangement, accentuating the colors and highlighting the sense of form.

Hilary Rosen

Materials

No. 6 round

No. 10 round

Making Sketches

IDEAS FOR PAINTINGS ARE ALL AROUND US. You never know quite when the urge will strike you to record a fleeting moment or capture a scene on paper. It is always useful to carry a sketchbook with you so that you can jot down images that strike your interest. If you are planning a still life painting, there are many variables to consider. You may want to play around with your objects and experiment with how the light falls on them. Sketches are an ideal way to try out various compositions before committing yourself to a full-scale painting. Although many artists work in charcoal or even pen and ink, pencil remains the most popular tool for sketching. Practice making different marks with a pencil; it is capable of an enormous diversity of line and tone.

Sketchbooks
Sketches can be as brief or as finished as you choose and can be in whichever medium you prefer.

HB pencil

2B pencil

4B pencil

Sketching pencils
Pencils vary in strength from "H," which stands for hard and produces a very soft line, to "B," which stands for black and produces a rich, dark line. "HB" is midway between the two. The 4B is slightly softer than the 2B, but any of these three pencils is fine for drawing with line, for hatching, or for shading.

Plastic eraser

Kneaded eraser

Modifying your drawings
You can delete pencil lines with a rubber or plastic eraser, but a kneaded eraser is better for removing pastel or charcoal. Form the kneaded eraser into a point to use with ease.

Hatching and highlighting
Practice different types of lines to suggest tone or create texture. Hatching and crosshatching (*above and right*) can be used to interesting effect in a drawing. If you want to create highlights in a pencil drawing, you can lift some of the lines or tones with an eraser.

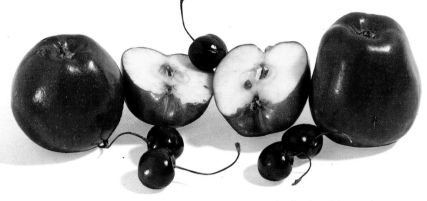

Studies of apples and cherries

The sketches on this page show some of the ways that you can approach a subject. It is a question of both how you look at your arrangement and how you choose to draw it. You can concentrate on the beauty of the shapes of your apples and cherries, for example, as in the very linear drawing below, or you can look for the spatial patterns they make or study the tonal contrasts of light and shade. A painting can consist of all these elements; making preliminary studies allows you to become aware of some of the possibilities that are available to you.

By pressing harder with your pencil you can modify the line to create a sense of form.

Line drawing

In the image on the right, the artist uses gentle fluid lines to describe the shape and features of the fruit. The seeds and cores of the cut apples are deliberately accentuated to echo the curved lines of the larger shapes. The stems of the apples and cherries also add to the rhythm and flow of the lines. This deceptively simple drawing is produced with a great degree of confidence and skill. You will need to practice a great deal to achieve this degree of mastery with your pencil.

These simple outlines are sufficient to capture the essence of the fruit.

Spatial study

The fruit seen in context against the dark background (*left*) and the whiteness of the paper beneath emphasizes the sense of three-dimensional space. The eye is led from the sharp horizontal lines in the foreground of the sketch into the darker recesses at the back. The inclusion of delicately modulated shadows anchor the fruit firmly on the table.

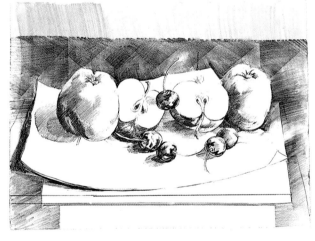

Charcoal sketch

This charcoal drawing (*right*) establishes the pattern of the dark and light tones. The addition of a piece of crumpled paper enhances the tonal contrasts. Modeling with charcoal is easy because you can apply the dark strokes swiftly.

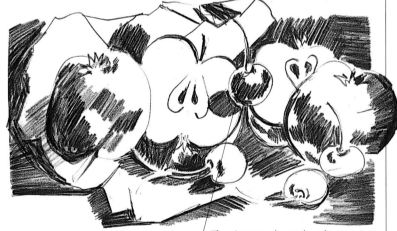

The vigorous charcoal marks suggest bold brushstrokes, making this sketch look quite painterly.

The shadows cast suggest a table top.

Highlights are made with an eraser.

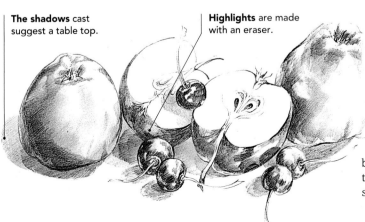

Study in composition

The drawing on the left is similar to the linear drawing at the top of the page although considerably more finished. The artist here is not only concerned with the outlines of the fruit, but she has also modeled the shapes to give them form and volume. The highlights on the cherries make them look glossy as well as indicating the direction of the light source. The placing of the fruit has been adjusted to make it look less static. The cut apple on the left is tilted to catch the light while its other half is moved slightly forward to break up the horizontal grouping.

GALLERY OF BRUSHSTROKES

BRUSHSTROKES ARE very important to painting: they are the notes that make up the tune of the piece, each stroke operating singly and also creating a rhythm with the ones next to it. It is with an understanding of this that Japanese painters train for so long in the art of making brushstrokes, learning how to hold the brush and how to feel the different movements in order to control and understand the marks that they make. In the West we have a range of brushes for all types of marks and effects. For example, a loose wash applied with a large flat brush creates an effect totally different from that of sharp staccato marks applied with a fine round brush. Learn to hold the brush not just with your fingers but with your whole body. The way you stand and the balance and lightness of your touch will all affect how you paint. The whole feel of a painting is created by the interaction of the marks and the brushstrokes.

Tsubaki Chinzan, *A Flower, from an Album of Twelve Studies of Flowers, Birds, and Fish, c.1830*
The Japanese artist Chinzan came close to the work of early masters in his painstaking brushwork technique and in the patterns created by the floral subjects. The painting owes its great vitality to simple purity of line.

Elizabeth Jane Lloyd, *Poppies in Blue Jugs*
Her training with a Japanese artist shows itself in the fluidity of Lloyd's brushstrokes. This work has great spontaneity and freshness; confident applications of color convey clarity and conviction, responding to and describing the moment.

Each brushstroke forms the outline of a petal or a stamen. The rhythmic individual strokes are controlled and distinct, allowing the pure white highlights of clean paper to shine through.

Dense washes of color have built up the tone of the vermilion petals complementing the dark centers, black with pollen.

Raoul Dufy, *Le Bouquet d'Arums, c.*1940

Dufy achieved his remarkable decorative effects by using dramatically varied styles of brushstrokes and patterns. A blue-and-lilac wash creates the space in which the bright calla lilies stand forward. Dark patterns created by leaves act as a foil to the orange and yellow of the blooms.

Wide strokes are made using the full breadth of the brush for the stems of the lily, in contrast with the fine detail created by "drawing" with the fine point of the brush.

Pure brilliant red is overlaid with blue-tinted body color to create greater depth and tone at the flower's center.

James Tan, *Chinese Cabbage and Mushrooms*

This painting was made quickly and surely, using a large brush and a very fine one. The Japanese brush, held upright in the traditional way, spreads out with each stroke. The darks come forward strongly, and a network of linking lines holds the beautifully balanced composition in place.

John Yardley, *Roses and Silver*

This subtle painting demonstrates a masterly use of whites to create light effects. Morning light from the window shines and sparkles on the white cloth, flowers, and lustrous silver. This brilliance contrasts with the cool green-gray shadows falling away from the light to merge with the blues and browns on the dark side of the room. Yardley has worked with a large brush to capture this dramatic effect.

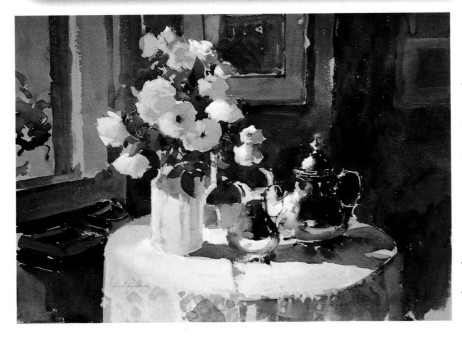

25

THE WORKING STUDIO

IF YOU ARE GOING TO WORK seriously as a painter it is important to set up a space of your own. Choose a position that is near a large window where natural light will fall on your work table or easel, but try to avoid direct sunlight since this will cast strong shadows in the room. To work into the evening, you should add extra lighting using daylight bulbs that will not distort the quality of your colors. It is also useful to have a sink for cleaning brushes and as a fresh supply of water for mixing your paints.

Allocate a time to work regularly. You should allow two or three hours to practice basic techniques, brushstrokes, and sketching, then increase the time as your interest and confidence grow. Create an atmosphere in which you feel at ease so that you can devote all your attention to seeing and developing your ideas on the subjects you are painting.

Essential equipment

You will need a chair or stool to sit on, and you could also use an upright chair as your easel, resting your drawing board against its back. Alternatively you might prefer to work with your board on your knee or propped up on a table. If you decide to invest in an easel, spend some time trying different models before you buy one, because you must feel confident about your choice. Try various layouts until you find the one that suits you best. A cart is useful for carrying paints, palettes, and pots of water. Keep some rags or tissues within reach in case you accidentally spill water or need to lift color washes from your painting.

Paul Newland

CREATING A COMPOSITION

TO CREATE A STILL LIFE composition the artist first of all decides on a theme, then selects several suitable items to construct a visually interesting entity. The overall structure of this composition should reinforce the theme, convey an idea, or suggest an ambience. For example, a low viewpoint may imply a dynamic tension, whereas a horizontal arrangement may evoke a quiet stillness. There are other devices you can employ that rely on close color harmony or contrasts, or unusual juxtapositions of shapes and forms. A device that is often used is the classical principle of the "Golden Section." In this, the painting surface is divided into what is felt to be harmonious proportions – a square and a smaller, upright rectangle – with the focal point of the composition positioned roughly two-thirds along, at the point where they meet.

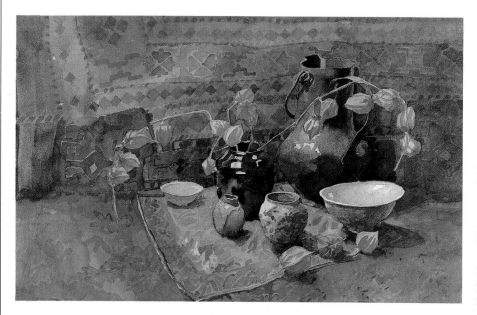

Off-center focal point

For her painting entitled *Chinese Lanterns*, Annie Williams has selected fabrics for the background and the foreground to complement the colors of the vases, dishes, and sprays of flowers. The fabrics provide the overall color scheme of soft, diffused hues: orangey pinks echo the colors of the Chinese lanterns. The blue, lilac, and yellow of the jars and dishes are also subtly echoed in the fabrics, creating a rhythm of repeated tones and colors. The fine overall tonal balance of the composition builds a strong visual harmony: the objects have been positioned slightly off-center, as the artist instinctively follows the ancient rule of the Golden Section (*see below*) – sometimes known as the "law of thirds" – in a visually pleasing arrangement, allowing the eye to move into and around the painting.

Applying the rule of the Golden Section

The dotted line on the rectangle (*right*) divides it into two proportional sections, a square and an upright rectangle, forming the basis of what is known as the Golden Section or the law of thirds. In painting, the point of visual interest is positioned along the upright vertical (roughly two-thirds along the picture plane), thereby creating a pleasing visual balance and harmony.

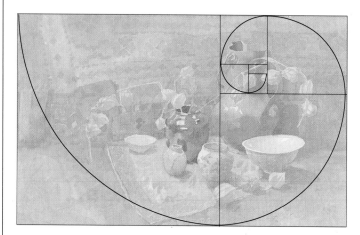

Rhythmic patterns

The arc placed over the painting on the left shows how the eye is drawn across and into the painting, both from left to right and from the front to the back of the composition. The main areas of interest lie within the arc, with the main focus resting in the second, smaller Golden Section formed by the "tail" of the spiral. Most artists use this principle intuitively, positioning the most significant area of their composition within the smaller rectangle.

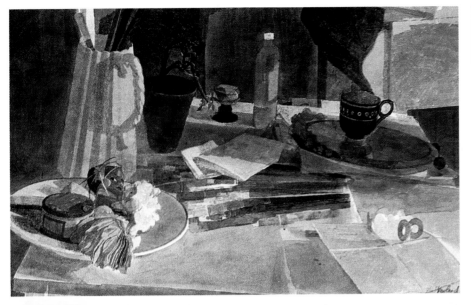

USING A VIEWFINDER

You can look through a viewfinder, using it like a camera lens to decide which section of a scene or arrangement to make the focus of your painting. A viewfinder will also help you decide which format (e.g., horizontal, vertical, or square) to use.

You can make a viewfinder with two L-shaped pieces of cardboard.

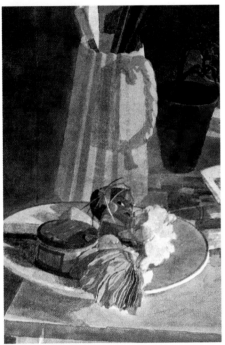

A sense of depth

There are many areas of attraction in this skillful painting by Paul Newland (*above*). The objects on the table extend from left to right, and to the back, drawing the viewer right into the composition.

Horizontal format

This elongated format (*right*) draws our attention to the bottle of oil and the teacup. The placing of the cup in the center of the image is somewhat disturbing, although the blocks of color make interesting patterns in the background.

Vertical format

By looking at the painting through a viewfinder you can select various aspects of it and other possible compositions. The vertical "portrait" format (*left*) shows you how different views and formats can transform the visual impact of a painting.

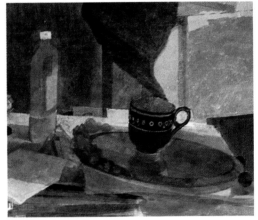

MIRROR IMAGE

A mirror is a simple aid you can use to check that your composition is visually pleasing. When you look at your work in the mirror, it forces you to see the image with a fresh eye, so that the tonal values in your composition are clear. Every painting should be tonally balanced, and this quality will register even when the work is seen reversed or even simply turned around to be viewed upside down.

The artist looking at a reverse image

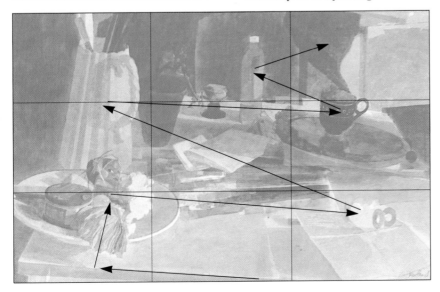
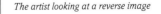

Making space

The grid and the directional arrows placed on the surface of the painting (*left*) show how the eye is drawn from the front to the back of the painting via many areas of visual interest positioned in the foreground, midground, and background. The artist has instinctively arranged the composition according to the Golden Section or law of thirds.

SELECTION VS INSPIRATION

ESSENTIALLY, STILL LIFES FALL INTO TWO MAIN categories – those that are arranged by the artist into a pleasing composition and those that are painted just as they are found, without artistic intervention. Although the former is by far the more familiar of the two, as in the traditional fruit or flower arrangements, there is a lot to be said for the inspirational painting – the one where the artist has been moved to paint a particular scene or setup because it is intrinsically beautiful or interesting. Each approach has its advantages: the arranged still life allows you to move forms around and play with aspects of lighting and tone until you are fully satisfied with the result; the "found" still life has an immediacy and vitality not possible with a controlled setup. To see a scene and be so moved by it that you want to paint it makes for a powerful painting indeed.

Hazelnuts
Autumn provides a richness of delights for the artist as nuts and berries fall to the ground.

Buckeyes
Nature abounds with colors and textures. Here the horse chestnut fruit combines both a rough, spiky shell and a smooth, shiny nut.

Hazelnut study
A fine pencil drawing overlaid with delicate washes of earth colors captures the sinuous rhythms of the hazelnut fruits.

Chestnut study
This broken twig with its hanging chestnuts inspired the artist to do a quick sketch. Notice how the line varies from strong dark lines for the spikes to lightly shaded areas for the soft inner skin of the shells.

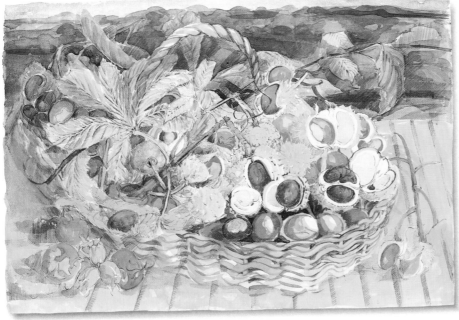

Medlar fruit
As leaves dry out, they change in texture and tone. The pale greens become darker and browner, and the soft, supple leaves become thin and cracked.

Elizabeth Jane Lloyd

Horse chestnuts and hazelnuts
Although arranged, this basketful of nuts retains an air of spontaneity, as though the artist has just collected all the nuts from the garden. The composition is made up of a symphony of greens and ochres, with the rounded form of the nuts being echoed in the curved weave of the basket.

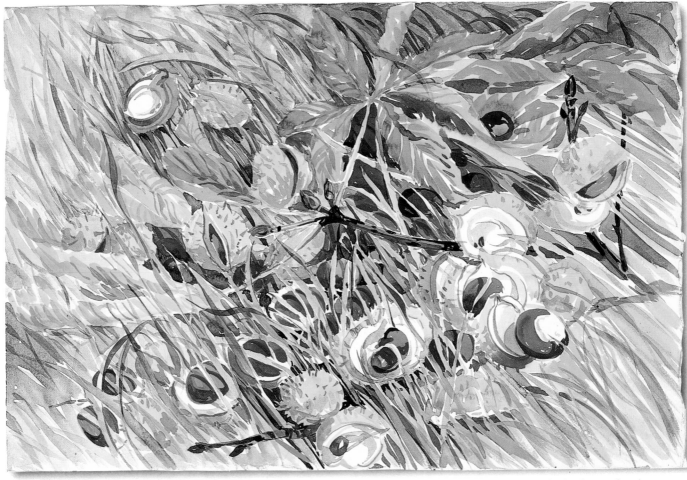

Fallen chestnuts
It would be easy to miss the beauty of these chestnuts nestling under a tree. Part of the skill of being an artist is learning how to look. There is a richness to this simple scene as the multicolored blades of grass twine their way around the buckeyes, forming almost abstract shapes and patterns across the surface of the grass. The whole arrangement is just as the artist found it. Moved by this unexpected find, she made a watercolor sketch of the scene *in situ*.

SEASHORE VISION I

Gray whelk shell

WHEN PUTTING OBJECTS together for a still life painting, the artist carefully selects and arranges them to construct a visually attractive composition. There are a number of variables to consider, including, the lighting, juxtaposition of shapes, color arrangements, and contrasting textures. On the following pages you will see how two very different artists have chosen to portray the same objects. The first artist used the unusual shapes of the shells, a coconut husk, and a piece of driftwood to form an asymmetrical pattern of triangles upon a triangle. The objects appear to pull away from the apex of the pen shell, creating a dynamic tension as if they are being washed away by the tide.

The two spiral shells, the coconut husk, and the piece of driftwood are placed on the flat, open pen shell in a tightly controlled arrangement.

1 ◀ Outline the composition using a soft 2B pencil. You may find a detailed sketch allows you to paint with more confidence later. Select your palette and mix all the colors you require. Establish the darker tones first. Use Burnt Sienna and French Ultramarine to create a deep gray for the shadows, then block in the area surrounding the coconut husk using pure Burnt Sienna.

2 ◀ Draw in fine lines for the husk using the tip of a small brush. Once these have dried, lay a dilute wash of Cobalt Blue over the line work. To create warmer tones, add a wash of Raw Umber over some areas of the husk. Because the colors will become lighter as they dry, you may need to return to them to add further layers of Cobalt Blue and Raw Umber. A softer effect is achieved when details are painted in before the wash than if details are laid over the wash. The layers of colors also enhance the solidity of the husk.

Coconut husk

3 ▶ For the driftwood, lay in a wash of Raw Umber and Yellow Ochre, using a medium-sized brush. Add a touch of Cadmium Red and Cobalt Blue using a wet brush, and then allow the colors to dry. To emphasize shadows on the driftwood, wash Cobalt Blue over the gold tones.

Bleached driftwood

4 ▲ Apply Raw Umber, Ultramarine, and Alizarin Crimson to the surface of the large pen shell. Dot gray and Alizarin Crimson into the foreground and background, then use a medium brush to blend in the colors, following the curve of the shell.

Materials

No. 4 round

No. 6 round

5 ◀ Add fine lines to describe the texture of the whelk shell using the tip of a small brush. Apply a further wash of Cadmium Red mixed with Crimson Lake to the pen shell, and then overlay its edge with a wash of Yellow Ochre.

Seashore still life

The painting has been created with subtly blended warm and cool tones in a fairly limited color range. The composition pulls the viewer into the center as the eye is led back and forth from shell to driftwood to coconut husk, in a balanced rhythm of movement. The use of cool shadows creates an illusion of the objects floating against the sandy ochre ground.

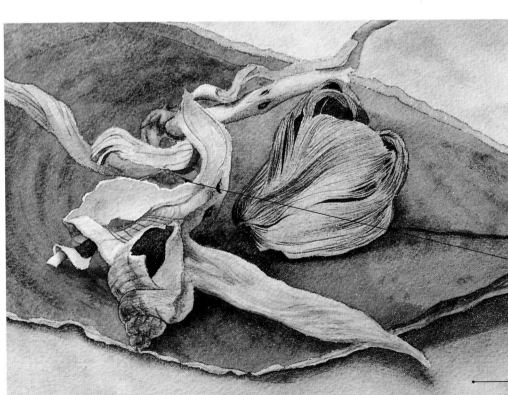

Small areas of clear white paper create the brightest highlights.

This still life was painted in a studio, but, by laying a flat wash of yellow ochre with grays and red dotted in, the artist has transformed the background to become a beach. This suggests that the objects were painted *in situ*, heightening the sense of immediacy and energy.

Rita Smith

SEASHORE VISION II

IN THIS SECOND COMPOSITION, the artist has involved the imaginative use of light effects to create an unusual scenario. Her intention is to render a painting of strong psychological impact rather than to portray the chosen objects as they are in a re-creation of literal reality. To accomplish this, she exploits the presence of long, eerie shadows, the central one appearing like a chameleon or iguana that is quietly slithering upward through the burning sand of the foreground toward a cool, beckoning sea beyond.

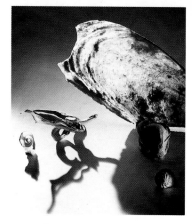

The selected shells, driftwood, and coconut husk are silhouetted in front of a strong light, placed at ground level, so that they cast long, dramatic shadows into the foreground.

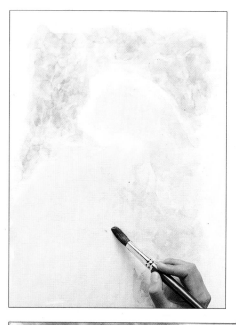

Gray whelk shell

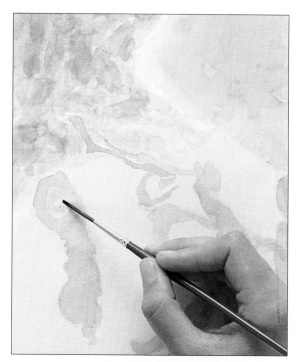

1 ◀ Use a large brush to build up light washes of Winsor Blue and French Ultramarine for the background. Block in the dark areas, leaving the edges undefined for a loose textural effect. Lay a wash of Carmine for the large shell and Indian Yellow for the midground. Dry the washes with a hair dryer.

2 ▶ Add a wash of Indian Yellow over the big shell, then build up the shadow areas and the small shell with Burnt Sienna washes. Dry with a hair dryer to prevent hard edges from forming. Define the driftwood with Brown Madder Alizarin and a gray mix of Ultramarine and Burnt Sienna.

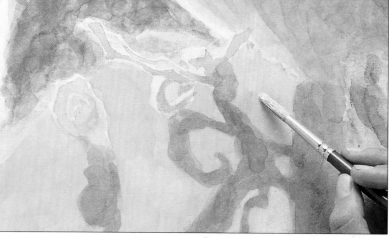

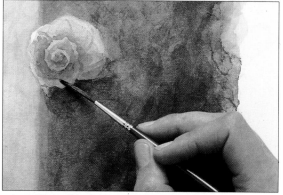

Pen shell

3 ▲ Deepen the blue background with a gray-mauve wash mixed from Indigo and Brown Madder Alizarin. Apply dilute washes of Cadmium Red to the foreground. Let the paper dry, then add gouache tinted with Cadmium Red and Indian Yellow.

4 ▲ Use a rigger (a long, thin brush) to paint the delicate details of the whelk shell with French Ultramarine. Use little curved strokes to describe the spiral pattern, and deepen the tone toward the center of the shell to give it a rounded effect. Add a touch of diluted Ultramarine to the shadow cast by the shell.

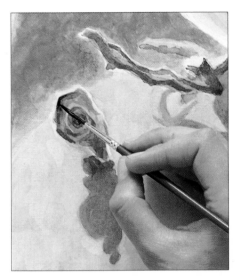

Broken shell

5 ◀ Add details to the broken spiral shell, then deepen the shadow falling in front of it, using Burnt Sienna and Brown Madder Alizarin to make the shadow echo the shell's form.

6 ▲ Add a dense wash of Carmine to the large shell, allowing some of the wash to run down onto the coconut husk. The touch of Carmine at the top of the husk gives the impression of a rosy light cast on it. Overlay the husk with a wash of French Ultramarine.

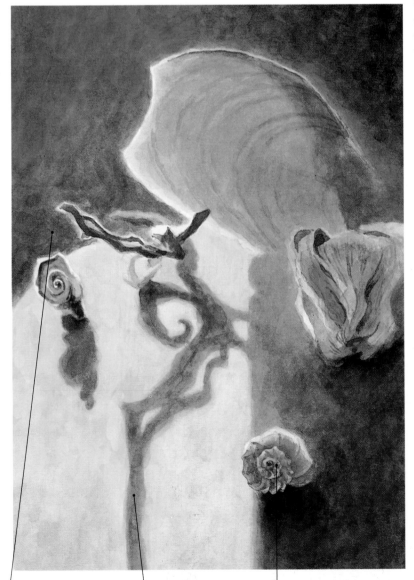

7 ▲ Use a rigger to paint strong veins of Carmine on the large shell. Then darken the background with a wash of Winsor Blue and French Ultramarine with a very large brush. To add dimension to the shell, apply a dilute wash of Indian Yellow to the rim; this produces a luminous quality, as if light were radiating from it.

Shadow play
This painting is in strong contrast to the realistic rendering of *Seashore Vision I*. The artist has used the objects as the central dramatic elements in the composition. Their colors are heightened for strong visual impact and are juxtaposed to create tonal variety within the painting as a whole.

Sarah Holliday

A thin wash of Burnt Sienna lights up the deep blue background on the left, heightening the sense of three-dimensional space.

The shadow cast by the driftwood dominates the image, mirroring the actual structure of the driftwood in a repeated pattern.

Luminous blues and intense crimsons are poetic interpretations of color rather than literal descriptions of objects.

Materials

No. 3 rigger

No. 12 round

No. 16 round

35

GALLERY OF COMPOSITION

THE ART OF GOOD painting relies to a great extent on composition – on the ability to place the focus of your painting correctly within the confines of your paper. Although most artists do this instinctively, there are certain rules that can be followed. The Greeks devised the "Golden Section," dividing a rectangular canvas into what were judged to be harmonious proportions – a square and a smaller, upright rectangle. The focus of the painting would occur where the square bordered the rectangle, roughly two-thirds along. Generally, as seen here, paintings with an off-center focal point are more aesthetically pleasing than ones where the focal point is in the center. In painting, this device engages the viewer and draws us into the heart of the picture.

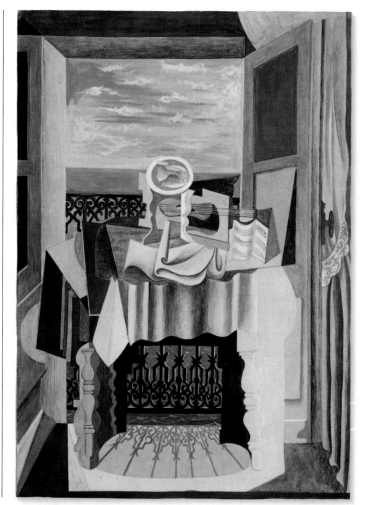

Pablo Picasso, *Still Life in Front of a Window, St. Raphael,* **1919**
A stylized violin, open music books, and a mirror create fluid shapes echoing the clouds and the sea. Black railings make stark patterns in front of the sea, and shadows of the railings are reversed in blue on the pink foreground. The composition is contained by the blue-green shutters and the gray ceiling, while the earth colors of the window frame lead the eye toward the sea.

Hercule Brabazon, *Still Life,* **c.1885**
Dark washes and rich tones are held back by a cascade of white fabric. The red roses positioned just off-center are balanced by the dramatic diagonal brushstrokes of Chinese White. These bold brushstrokes stand out on the tinted paper, imparting drama and richness to the painting.

Rita Smith,
The Studio
Many artists paint their own studios, perhaps because it is where they are often inspired and work begins. In this painting, images are encompassed or framed by other images. The drawing board rests on an easel, and an outline of masking tape breaks up the surface of the board. Strong verticals and horizontals are created by the stand of the easel, the board, and the frame of the mirror, dividing the composition into thirds. Reflections in the mirror over the tiled mantlepiece add depth to the painting; the scale rather than the tone tells us that the two paintings on the far wall, seen through the mirror, are most distant from us.

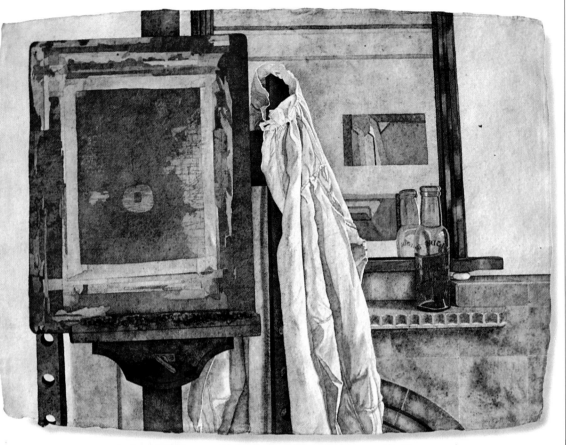

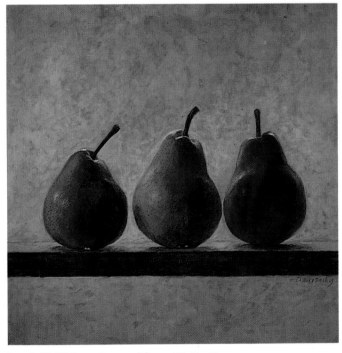

Claire Dalby, *Three Pears on a Shelf*
The individual pears that make up this simple composition have been placed so that they please us with their shapely simplicity. The placing of both the pears and the shelf has been carefully planned. The painting is divided into thirds by the shelf that holds the pears suspended in midair. The artist has also positioned the light source very deliberately so that light pours in from the left, revealing the pear on the far left most distinctly. The right-hand pear is the darkest of the three, held in place by the deep shadow falling on the shelf. The simplicity of this painting is deceptive, however – details such as the angle of the stalks of the fruit have been planned in order to draw us in and focus our attention on the exquisitely patterned red and green skin of the pears.

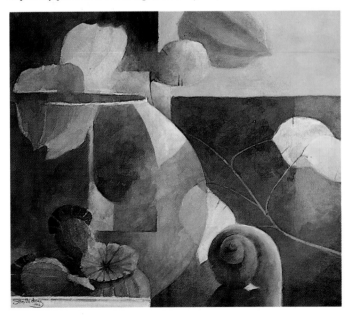

Sarah Holliday, *Composition with Snail*
This study of poppy heads, Chinese lanterns, a silver dollar branch, and a snail shell relies on organic, curving shapes. Curves work most powerfully when set against straight lines and geometric forms, and they are well balanced in this composition. Some edges, for example, where the light hits the round bowl, are strong and bold; others, such as the glowing forms of the Chinese lanterns, are intentionally softened. The spaces between the objects – known as negative space – are as important as the objects themselves, creating subtle patterns within the painting.

LIGHT AND FORM

LIGHT TRANSFORMS and enriches everything we see – light is life, as painters say. When light falls on any surface or object, the effect changes our perception of forms profoundly. Light and shadow create new shapes, new visions, and new depths. Everyone will have experienced the serendipity of a shaft of light or sunlight falling on a vase of flowers or a bowl of fruit. In still life painting, the artist strives to capture this fleeting beauty by skillful manipulation of paint and tonal balance. It is the quality of the vision that drives an artist to paint, to portray the incandescent quality of light on forms. Form is essentially the shape and the three-dimensional appearance of an object. In painting, forms are achieved by investing shapes with varying degrees of light and dark colors or tone to depict highlights, midtones, and shadows. When setting up a still life, try manipulating the light to add interest to the forms; place the light source at different angles until you like the effect.

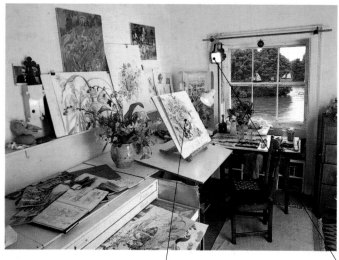

Choose a working area where you are not in your own shadow. An easel allows you to alter the angle at which your paper sits.

A halogen spotlight supplies a superb quality of light, comparable to daylight. The colors of your subjects and paints remain true.

Lighting your studio
Natural light is vital in a painter's studio; traditionally, a northern aspect is thought to be the best. Whether or not you can achieve this, try to ensure that your workspace has a large window that admits as much constant daylight as possible. There are many advantages to indoor lighting, because controlled light sources allow you to manipulate your environment. You can use artificial lights to simulate daylight, to create unusual effects, or simply as a constant light source so that you can work into the evening.

ANGLES OF LIGHTING

If you take a simple subject – here an elegant china cup and saucer with a silver teaspoon – and experiment with different lighting effects, you will begin to appreciate how the local (true) color of any objects changes in different light conditions. When the teacup and saucer are viewed in a fairly even, diffused light we see their innate forms most clearly. We also see the local colors of the china cup and saucer, unaffected by shadow. By changing the angle of the light, we can distort the color and the appearance of the objects.

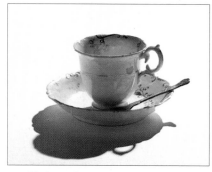

Backlighting the teacup
Powerful light shining from behind the cup throws the white bowl of the cup into deep shadow; the cup's interior appears to glow in a deep orange-gold. The local color of the china is considerably altered.

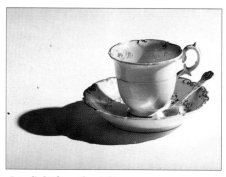

Low light from the right
Caught in a beam of light, the teacup casts a long shadow across the saucer and onto the white tabletop. Light hits the bowl of the teaspoon and is reflected back onto the cup, creating a bright silver nimbus of light.

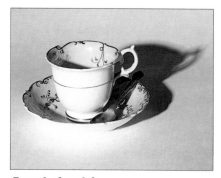

From the front left
In this lighting arrangement, the shadow echoes the forms, duplicating the outline of the cup's handle. However, the teaspoon's form and color are almost lost in the shadow cast by the cup.

Lighting a still life composition

When you are setting up a still life, the lighting is often as crucial as the selection of objects. If you compare the painting *Seashore Vision I* with *Seashore Vision II* (pp.32-35), you will see how dramatic lighting transforms the same five objects. Here a simple tea tray, complete with teacup and saucer, napkin, plate, knife, and fruit tart, has been placed on a batik cloth. Strong lighting picks up the brilliant white china and creates highlights on the rim of the cup and the raised folds of the napkin. Deep shadows occur within the folds of the napkin, and the shadow of the fruit tart subdues the bright silver knife. Light and shadow effectively unify the composition, making connections between the separate objects.

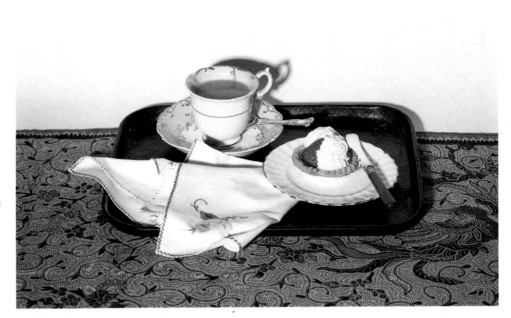

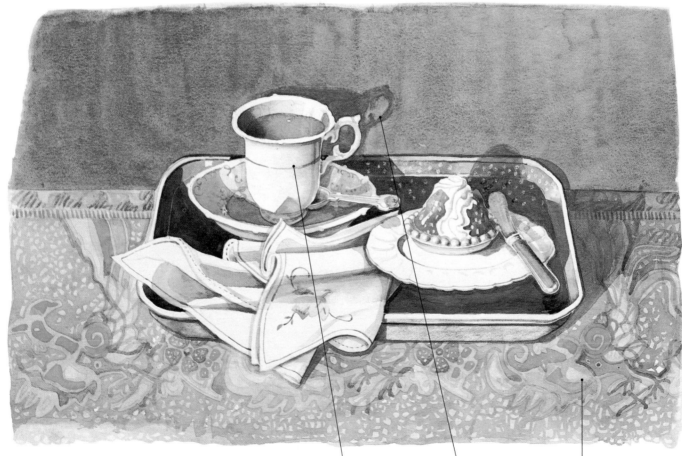

Margaret Stanley

Afternoon tea for one

Every painting relies on color and tone for its effect, and these factors in turn depend on light. It is helpful if both the lighting of the subject and the light used by the painter to work by can be controlled. During the course of a day, natural daylight will produce very different effects; the angle of sunlight will change, creating new highlights and shadows throughout the day. The tea tray above has been lit by artificial light directed at the subjects from a position at the front of the still life and to the left-hand side. Shadows fall to the right on the batik cloth and behind the cup.

Golden filigree decorates the china cup and serves to accentuate its form; the fine gold line that encircles the cup adds to the sense of perspective.

The shadow cast by the handle of the cup echoes the form of the cup itself and creates a repeating rhythm of circles and ellipses within the painting as a whole.

A batik cloth makes an intriguing foreground. The painter has simplified the elaborate pattern but has retained the muted mauves and golds of the fabric.

TONAL PAINTING

TONE IS THE DEGREE OF DARKNESS or lightness of an object. It is important to understand how tone works because it defines form and helps to create a three-dimensional image on a two-dimensional surface. Although every object possesses its "local" or true color, this color will be altered by the effect of light and its relationship to other colors. For example, the red petals of a rose will range from pink to violet to almost black, depending on how the light hits them. White objects make good subjects for tonal studies since they force you to look at the enormous variations in a single color. In the photograph below, notice how dark the areas in shadow become, so that the white marble appears virtually black in places. When painting in watercolor you may want to let the color of the paper show through for highlights, or rely on the opacity of white gouache to cover darker, toned paper.

Ingredients for "Garlic Mushrooms".

1 ▶ Draw the ramekin, garlic, and mushrooms in Burnt Sienna with a very small brush. Use French Ultramarine to add blue tones to the dish and then fill in the areas of shadow in a mix of the Ultramarine and Burnt Sienna. You can soften the tone by "painting" water over it.

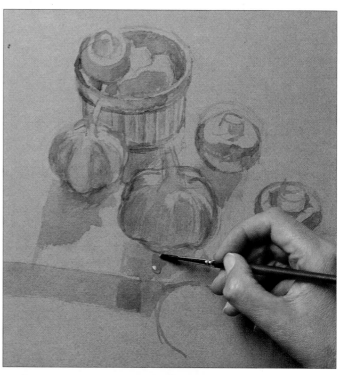

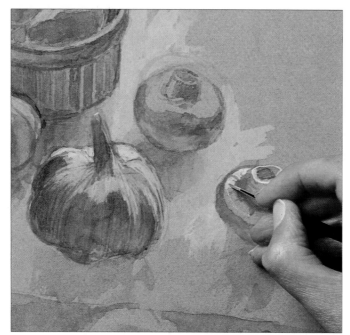

2 ▲ Mix Permanent White gouache with a little gray to paint the marble surface. Add veins to the garlic cloves in Burnt Sienna then, with a small brush, add highlights to the mushrooms and to the rim of the ramekin using Permanent White gouache. Deepen all the shadows to build up tonal contrasts. As highlights are added, the composition becomes more asymmetrical and interesting.

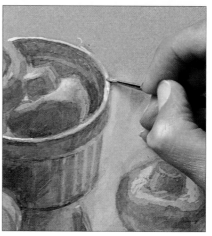

3 ◀ Define the fluted sides of the ramekin with a gray mixed from French Ultramarine and Burnt Sienna, and then highlight the rim of the ramekin with Permanent White gouache. You need to use gouache for highlights since the paper surface is quite dark and needs to be obscured in order to create a strong white.

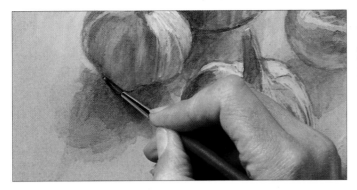

Raw Sienna

4 ◀ Soften the outlines of the garlic bulb by going over it with a wet brush. Add green tones to the ramekin and mushrooms using Raw Sienna with French Ultramarine. Paint in the background with a mixture of French Ultramarine and Burnt Sienna.

Burnt Sienna

Alizarin Crimson

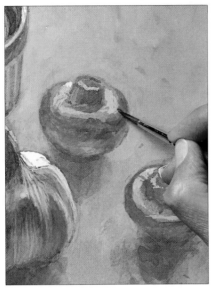

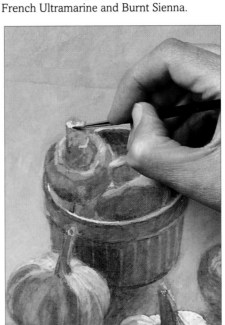

French Ultramarine

5 ◀ Apply Burnt Sienna toned down with a little French Ultramarine to add detail to the mushrooms. Define the marble slab and lighten its edge in the foreground with lighter gray mixed from white gouache.

Permanent White gouache

6 ▶ Working with gouache allows you to change your painting at a late stage. Here you can extend the mushroom stalk to strengthen the whole composition.

Ivory Black

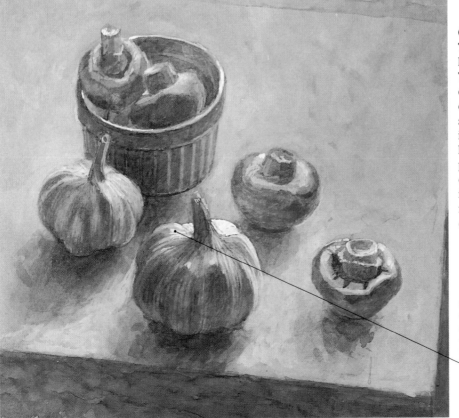

Garlic mushrooms
This simple subject, with its strong back-lighting, is subtly and effectively placed. The tonal quality of the near and far edges of the board are very well defined, creating an extremely strong sense of three-dimensional space. The triangle of the marble slab and its interaction with the edges of the painting hold the round forms in the forefront of the picture plane. Darker tones on the near side of the objects make the solid forms strongly felt and establish the quiet, thoughtful mood. Each element is meticulously drawn, resulting in a striking study.

Highlights painted with Permanent White gouache shine on the far side of the garlic bulb closest to us.

Claire Dalby

Materials

No. 0 round

No. 4 round

CREATING FORM AND TONE

A child's school bag disgorges its brightly colored contents to create an intriguing composition of strong forms and shadows.

THERE IS REAL DELIGHT in discovering a pleasing subject in a mundane or familiar situation. A briefcase, a basket, a purse, or a school bag creates a challenging, complex composition. To break a composition that appears too square or regular, try the effect of introducing a diagonal or a linear object such as an umbrella. In this subject, a cricket bat emerges from the bag, creating a strong horizontal line. Shadows are slowly built up with layer upon layer of washes, while fine lines drawn in with a rigger brush create definition and detail to pull the composition together.

1 ▶ Take a soft 4B pencil and outline the forms of the objects, making sure that they are in proportion. If you wish to modify the arrangement, for example, changing the position of the toy rabbit, now is the time to do it. When you are satisfied with your sketch, begin by blocking in the larger areas of bold color. Work with light washes and a large flat brush.

2 ▶ Define the main zones of color and tone by building up washes. Wash in the black interior of the bag using Payne's Gray with Cobalt Blue and a little Hooker's Green with a generous amount of water. Leave white highlights on the shiny spinning top and the buckles unpainted.

4 ◀ Mix Cobalt Blue and Ivory Black with a touch of Indigo, and wash in areas of shadow using a broad wash brush. Use the soft pencil outlines to guide you around the bats, balls, and spinning top. Burnt Sienna and Raw Umber are applied with a small round brush to create the shape of the rabbit.

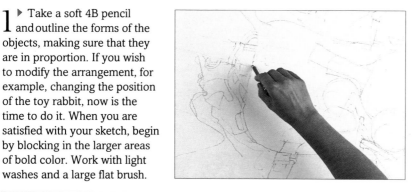

3 ▲ Mix up a dense black from Payne's Gray, Cobalt Blue, and a little Hooker's Green, and use a rigger to draw in the panels of the baseball cap. Then outline the exercise book using Vermilion, applied thickly with a rigger brush. The pencil marks look intrusive here, but can easily be erased as the painting begins to take form.

5 ▶ Begin to add fine details to the composition, such as the red lettering on the comic book and the baseball hat in Alizarin Crimson. Allow the painting to dry completely before erasing the pencil marks using a kneaded eraser. Increase the three-dimensional quality of the painting by adding darker washes of deep gray to create areas of shadow and tone.

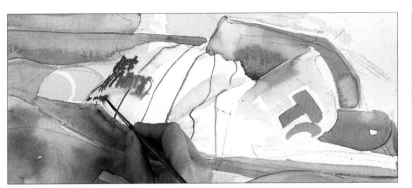

Materials

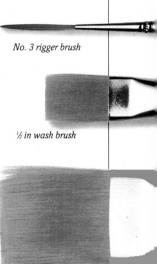

No. 3 rigger brush

½ in wash brush

1in wash brush

6 ◀ Overlay the areas of shadow with less dilute washes of blue-black made from a combination of Cobalt Blue and Ivory Black with a little Payne's Gray. Give the dark areas a crisp outline using the same blue-black wash, applied with a rigger. Use a little Hooker's Green to darken the foreground of the painting. Add fine detail such as the buckles of the bag and the laces of the shoes using a rigger brush.

7 ◀ Intensify the shadows falling across the ground and within the bag by applying a wash mixed from Ivory Black, Indigo, and Hooker's Green with a flat brush. A dark wash throws into relief the white highlights (clear paper) on the top and baseball cap.

Domestic scenes

This familiar collection of "found" objects has been composed so that the balls and the round Ping-Pong paddle build up fluid rhythms within the composition. The handle of a cricket bat breaks out of the open bag, creating a more informal composition. The furled comic book and school exercise book create shadows within the bag. Areas of white highlights such as the baseball cap, the spinning top, and the soft brown of the toy rabbit are thrown forward in contrast with the graded washes of the shadows.

Light washes are painstakingly laid to give the painting its tonal quality.

Pigment dries with a hard edge on the heavy unstretched textured paper. Fine lines such as the shoe-laces stand out clearly.

Pam Garnett-Lawson

43

NEGATIVE SPACE

WHEN YOU LOOK AT A COMPOSITION as a whole – rather than focusing purely on the objects being painted – you start to view it quite differently. Instead of seeing it in a flat, linear way, you begin to appreciate how the painting works three-dimensionally, with some details coming closer to you and others seeming farther away, and with the spaces between objects being integral to the look of the whole. Before embarking on a still life, study the "negative spaces"; it is only by viewing the positive and negative shapes together that we can learn to see, and to paint, with maturity.

The vivid flowers and dark foliage of exotic succulent plants mesh together in front of folds of brilliantly colored Indian sari silk.

1 ▶ Make a drawing of the composition. The criss-crossing pattern of leaves is quite complicated, and you may find that you can simplify the plan for the painting by drawing in the spaces between the leaves, where the turquoise and purple shine through. Block in areas of blue using a Manganese Blue wash, applied with a large brush. Use a small brush to paint in the smaller "negative shapes." Build up the blue tones with Cerulean Blue.

ALTERNATING IMAGES

This simple image demonstrates the idea of negative space – sometimes you see a pair of faces, sometimes a white vase on a dark ground. The two subjects are so perfectly balanced that it is difficult to decide which is the foreground and which the background. In most paintings, foreground and background need to be read simultaneously to see the whole.

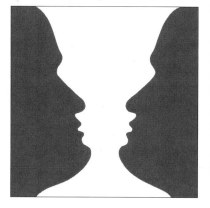

2 ▶ Outline the yellow-gold patterns on the silk with a dilute wash of Yellow Ochre, using a small brush. The gold panel helps to define the folds of the fabric as it falls. Use a wash of Cadmium Red to start blocking in the red of the fabric.

3 ◀ Blend French Ultramarine with Sap Green for the fleshy leaves of the cactus. Already the soft greens have begun to interact with the fiery red of the silk. Working wet-in-wet (*see also* pp.20-21), lay in the striped patterns of the cactus leaves using a small brush. Paint in the pale pink flower of the cactus using a dilute wash of Alizarin Crimson. Then mix Cadmium Red with Alizarin Crimson and a little Cadmium Yellow, and paint in the form of the deep coral flower on the left.

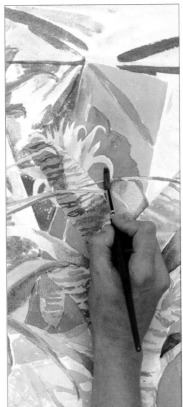

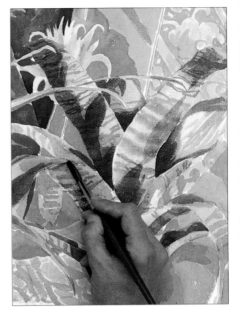

4 ▲ Paint in the network of spiky leaves using Sap Green with a little Viridian. Deepen the shadows with a more intense green. Darken the larger leaves using Ultramarine mixed with Sap Green – their dark forms will throw the coral flower forward in space.

5 ▶ Alternate between working on the plants and the background seen behind them. Deepen the tone of the red fabric, overlaying the first wash with an intense wash of Alizarin Crimson mixed with Cadmium Red, applied with a medium brush.

6 ▲ Paint in the shadows falling on the cactus using a wash of French Ultramarine with a little Manganese Blue for the leaves in deepest shadow, working with a medium brush. Add a little Sap Green to brighten the wash and suggest the shadows cast by the bright overhead light.

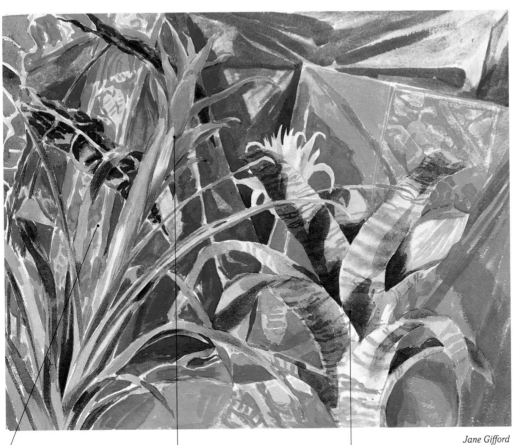

Jane Gifford

The intricate patterns that appear on the silk have been carefully worked out in pale yellow and then overlaid with Yellow Ochre.

Notice how effectively the deep coral red flower stands forward in space against the powerful turquoise blue of the silk sari.

By overlaying the gentle green of the cactus leaves with a blue wash of French Ultramarine, softly defined shadows are created.

Full of Eastern promise

This jungle of exotic plants forms a complex network of leaves and flowers against a rich backdrop of brilliantly colored sari silk. Working first on the fabric, then on the plants, and then alternating between them, the artist ensures that the elements of the painting receive equal shares of our attention. Curving shadows cast by the leaves appear as deep red echoes of the forms of the leaves themselves, and the blue of the silk has been accentuated by the addition of an intense wash of Manganese Blue over the shadowed areas. Forms, shadows, and background coexist in a painterly unity.

Materials

No. 4 round

No. 6 round

No. 9 round

45

GALLERY OF PERCEPTION

EARLIER IN THE BOOK we looked at watercolor techniques for painting still life. Although important, techniques are only part of the creative process. A painting is essentially a form of expression – it can convey ideas and feelings: joy or sadness, excitement or serenity. To be able to express yourself in paint you need to follow your instincts and give rein to your imagination, so that you paint what you see and feel. Trust your own intuition – your personal vision will impart to the viewer an enriching, new, fresh way of seeing. You might not paint a masterpiece, but you can create a piece of the world as you see it, in all its richness and infinite uniqueness.

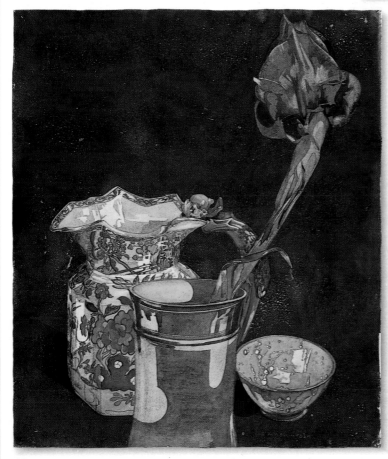

Philip O'Reilly,
Kusadasi Kilims
This unusual still life subject was developed from a series of studies O'Reilly made in a carpet shop in Turkey. The deliberate lack of perspective allows the kilims to become an almost abstract pattern of rich, stratified colors.

Light enters obliquely from a nearby window, softening the colors and texture of the densely packed kilims.

Charles Rennie Mackintosh, *Grey Iris, c.1922-24*
Originally trained as an architect, Mackintosh brought his fascination with aspects of structure and pattern to his painting. Here, he draws the viewer's attention to several interesting contrasts of forms, textures, and colors. The streamlined shape of the smooth silver mug, positioned in the center between an elaborately decorated pitcher and a small round painted china dish, creates an aethestically balanced composition of contrasts. The grayish purple iris looming off-center above the mug echoes the color of the metallic luster, thus establishing its relationship with the mug. Its soft bulbous organic shape also acts as a splendid foil to the manufactured objects.

Paula Velarde, *Turkish Rug*
The viewpoint, from above the vase, creates an unusual angle of vision. The richly patterned rug with the chair leg settled upon it offsets the vase with the sprigs of silver dollar almost exploding out of it. The ochre marks across the base of the vase hold the two planes together, creating a sense of space. A loose, instinctive use of color, applied wet in wet, makes this painting visually exciting. The brushwork is varied and dynamic, ranging from very fine pale strokes to strong lines and washes of vibrant color that transform household objects into a dramatic image.

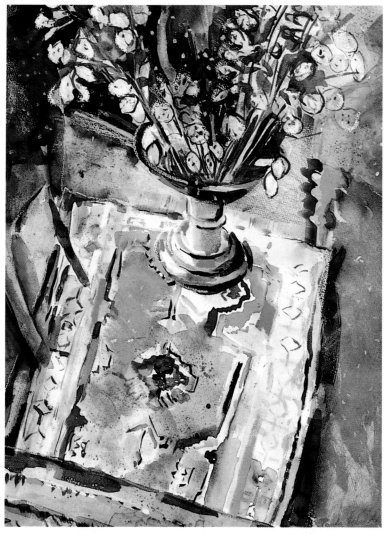

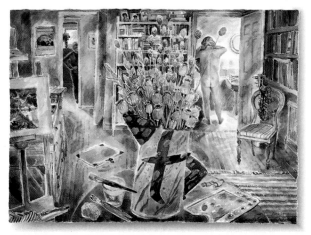

June Berry, *The Bird Jug*
The scale of the jug in this painting has the effect of dwarfing the two figures in the background, while shafts of light create an interplay of diagonals leading the eye back and forth between the jug and the figures. The painting relies on a series of repeated patterns – the jug's handle echoes the angle of the figures' arms; the chair, the portfolio, and the palette produce a zigzag motif that is repeated in the surface pattern of light and tones seen across the room.

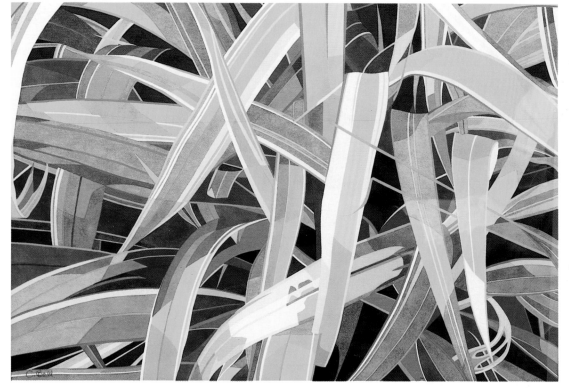

Catherine Bell, *Striped Leaves*
The interest of this painting lies in the dramatic change of scale and use of color. When examined in minute detail, any subject can become an intriguing, dynamic interaction of colors or shapes. Here, interesting negative shapes created by the intricate, interwoven leaves become part of a complex pattern of twisting and turning forms. Warm colors remain closest to us, while the cool colors retreat into the dark space. It is the dark negative spaces that bind the tangle of linear shapes and colors into a unity.

TRANSPARENT PAINTING

WATERCOLOR PAINT IS PARTICULARLY SUITED to capturing the effects of glass or transparent objects because of its own innate translucency. When you lay a wash, or a thin layer of watercolor, light rays penetrate to the paper surface and are reflected back through the transparent paint film, allowing you to see a thin veil of color. You can lighten a wash by increasing the proportion of water to pigment, or darken it by decreasing the amount of water. By laying further washes, you can build up tones or create new colors. When painting transparent objects, however, apply washes of color sparingly and work with light colors first, so as not to muddy the purity of the hues. The evocative painting below shows how to depict the solidity of forms that are essentially transparent.

An intriguing collection of glassware catches and reflects light in the artist's studio.

1 ▶ Lay a dilute wash of Indigo and Yellow Ochre in the window. Next, block in the window frame with a brown wash. Wait for the paint to dry before you lay in a green overlay to describe the roundel. Then define the edge with a gray wash.

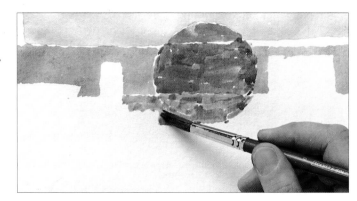

2 ▲ With the same gray, lay a wash in the area within the glass bell jar. Leaving a tiny margin next to the gray area to suggest a reflection, put in a wash of Cobalt Blue, Lamp Black, and Indigo for the foreground. Dry the blue paint with paper towel to prevent it from seeping into the gray.

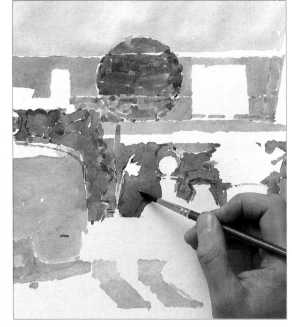

4 ▶ Paint the rose-colored glass with a diluted wash of Rose Madder. When the wash dries, lightly paint in the stem with a small brush. The rather distorted form and color of the stem will accentuate the transparent quality of the pink glass.

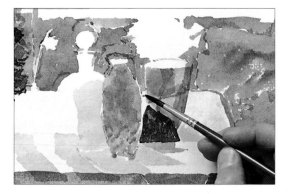

3 ▲ When applying the gray wash for the wall in front of the window ledge, reserve some areas of the white paper as highlights. These light up the tones and add a glow to the painting. Dilute the gray to paint in the sunlit window ledge and tabletop.

5 ▶ Use Light Red mixed with Rose Madder and Indigo to block in the shape of the angel mobile. Displayed in midair, it contributes to an illusion of depth, a suggestion of space beyond the window. The angel also breaks up the blue and gray horizontals in the foreground and mid-ground, leading the viewer's eyes upward from the tabletop.

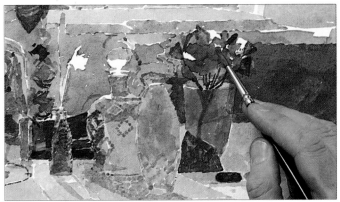

6 ▲ Paint in the petals of the violets with a medium brush using a mixture of Rose Madder and Indigo. For the leaves, use a wash mixture of Cadmium Yellow and Cobalt Blue.

7 ▲ Now that the paint on the body shape of the angel has dried, return to it to add details to the sleeves using Cobalt Blue. Finally, outline the head of the angel with Brown Madder Alizarin. Also fill in the angel's reflection on the window.

Reflections on glass
The cluster of objects in the foreground arouses our curiosity and draws us into the room toward the bright window. The artist is concerned with both the reflective qualities of glass and with the mood evoked by the scene. The visual poetry of the subdued colors create a sense of great stillness and calm, enticing the viewer into contemplation, to reflect, on the transience of the material world and the tranquility of the ethereal.

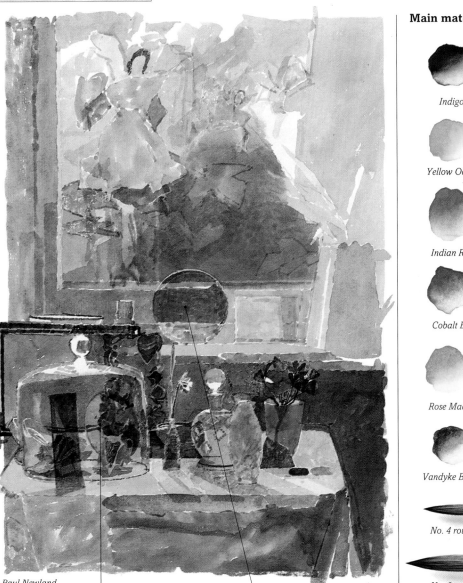

Paul Newland

The light washes on the glassware show them off to advantage. Other objects are visible through the vases, and bottles, and the bell jar – a myriad of mysterious images.

The hues of the green glass roundel vary in their intensity to indicate the reflections of solid and transparent materials against which it rests.

Main materials

Indigo

Yellow Ochre

Indian Red

Cobalt Blue

Rose Madder

Vandyke Brown

No. 4 round

No. 6 round

No. 9 round

49

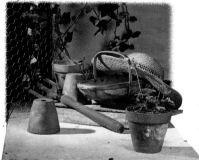

Arrangement of potted plants and gardening equipment

OPAQUE PAINTING

ALTHOUGH WATERCOLOR PAINTING relies heavily on the translucent nature of the paint, building up colors in layers, not all watercolor paint is designed to be used that way. Gouache, also known as body color, is an opaque watercolor paint containing a far greater density of pigment than traditional watercolor. It can be applied thickly, somewhat like an oil paint, or heavily diluted, like a denser version of watercolor paint. It can be used in conjunction with other watercolor paint to create highlights, or it can be used on its own, as in the painting below. Mixing a little gum arabic with your gouache pigments will make them more luminous.

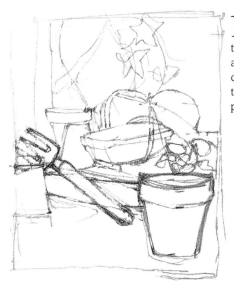

1 ◀ Arrange your gardening items into a pleasing composition and then make a pencil sketch of the arrangement. When making a complicated setup, it is important to get the different shapes and proportions right at this early stage.

2 ▶ Use a medium-sized brush, such as a No. 5, to start filling in the background. Block this in quickly so that you are not distracted by the white of the paper. Mix brown from Spectrum Red, Spectrum Yellow, and Lamp Black, and make the cool gray of the wall from white with a touch of French Ultramarine.

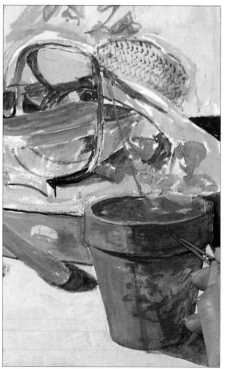

3 ▶ With the smaller brush, outline details such as the basket and the rim of the hat. Draw in the ivy shoots with a mixture of the Ultramarine and Spectrum Yellow, adding some Raw Umber for the darker leaves. Once all the main areas are covered, it is a question of adjusting the color balance. Work from the outside of the painting into the focus and highlights, building up darker tones to give greater definition to each form. If the colors seem a little flat you can make them brighter by adding gum arabic. Mix half a teaspoon of gum arabic with the same amount of water, and use this to dilute your paints. Gum arabic keeps pigments moist as well as making them more luminous.

4 ▶ Start refining your painting, working over the composition as a whole. Add details using the tip of a No. 3 brush. Although the ground was blocked in fairly quickly, the finer detail should be painted in slowly. Work on the flowerpot and the wooden stand behind it to create a sense of perspective. Adding lights and darks to the pot will make it appear more three-dimensional and make it stand out from the other items in the arrangement.

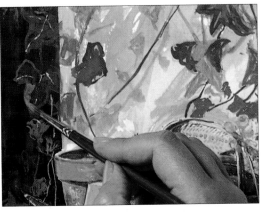

5 ▲ The woven nature of the sun hat demands careful treatment, so use the finer brush to accentuate the pattern. Use darker colors for the areas in shadow and a mix of white and yellow for the highlights.

6 ▲ Mix Yellow, Black, and French Ultramarine gouache to create an active, interesting pattern of hanging ivy for the background.

7 ◀ Use Black to pick out the plant's stalks, and Crimson and White for the flower bud, changing the dilution to reflect the tones.

In the garden

The depth of color and range of tones in this gardening still life are achieved by underpainting the whole in muted earth colors. Because of the opaque nature of gouache, the artist has been able to add lights to darks rather than simply building up tones as in traditional watercolor painting. She has also been able to work into the painting at great length, modifying tones, lifting out details with blotting paper, and blending colors to achieve the range of colors and textures.

White gouache has been added for the highlights. In traditional watercolor techniques, highlights would be created with the white of the paper so that these would be "first thoughts" rather than "last thoughts."

Materials

Indigo

French Ultramarine

Raw Umber

Alizarin Crimson

Spectrum Red

Spectrum Yellow

Zinc White

Lamp Black

No. 3 round

No. 5 round

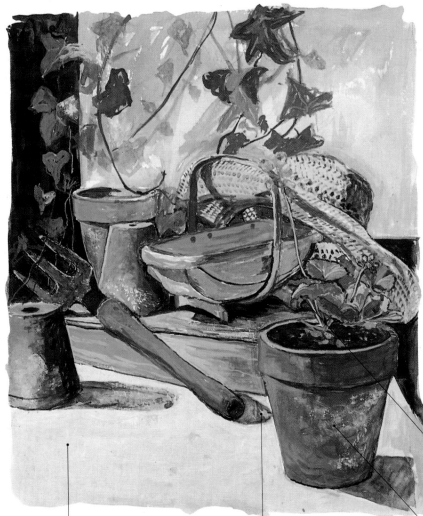

Carolyne Moran

The artist has blended a mix of whites and very diluted earth colors into the table using her fingers.

Sharp shadows help to define the sense of form.

Notice how many colors have been used on the pot.

GALLERY OF PAINT TYPES

Y OUR CHOICE OF WATERCOLOR medium is integral to the appearance of your painting. If you want to capture the quality of glass or water, the translucency of traditional watercolor is perfect since it allows the underlying color to show through. Gouache, with its greater concentration of pigment, is ideal when you wish to create denser colors or add highlights to toned paper.

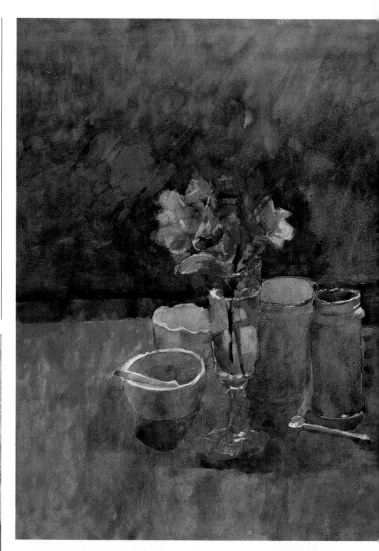

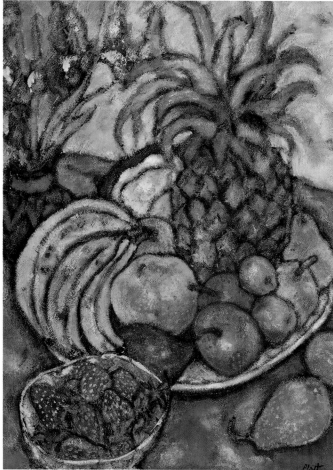

Lorraine Platt, *Pineapple, Irises, and Strawberries*
Platt has used gouache here, exploiting its opaque qualities and somewhat matte appearance to create an essentially flat surface. Distant fruits float on the picture plane, challenging our notion of objects receding in the distance.

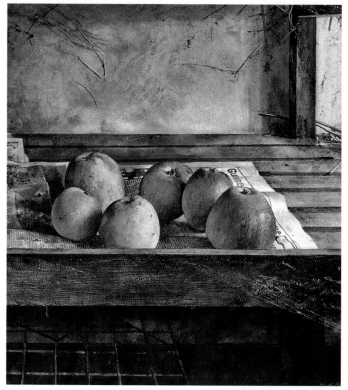

Martin Taylor, *Apple Stores II*
Gouache and traditional watercolor combine to great effect in this powerful "found" arrangement. Subtle layers of translucent color add solidity to the apples, while white body color models the underlying newspaper, contrasting with the shadow below.

Christa Gaa, *Camellia Still Life*
Watercolor has been applied densely in layers to conjure an intimate scene glowing with light and warmth. Shades of earthy browns and orange-reds dominate and set off the earthenware to advantage. The camellias break up the expanse of browns, as do the touches of pale gouache, which bring out the highlights on the objects.

The simple forms of the camellias break into the subtly blended far wall.

Dry brushstrokes of gouache stand out particularly clearly against the dark background.

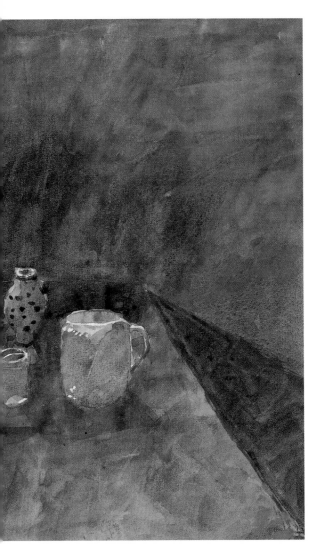

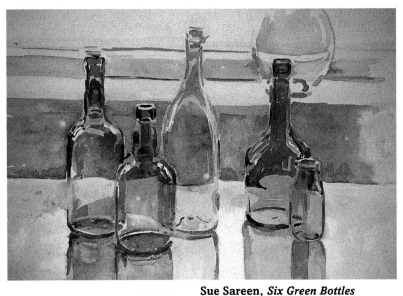

Sue Sareen, *Six Green Bottles*
Watercolor is the perfect medium for suggesting the transparency of glass. Dark accents and white highlights define the bottles, while negative shapes between them become equally important. Here, masking fluid was used to protect the areas of bright reflected light. The sill, wall, table, and finally, the bottles themselves were washed in with loose, free brushstrokes. Notice how the quality of the bottles is suggested by highlights and by the distortion of the table's edge by the glass.

Giovanna Garzoni, *Still Life with an Open Pomegranate*, c.1650
This still life was painted on parchment with egg tempera, a painting medium consisting of pigments mixed with egg yolk, popular before the advent of oil paints. Using the full tonal range of a limited palette, Garzoni has beautifully portrayed the subtle variations of colors and textural contrasts in this composition of natural objects. The exquisite gemlike flesh of the pomegranate, encased in its rough ochre skin, rests on a contrastingly smooth marble dish.

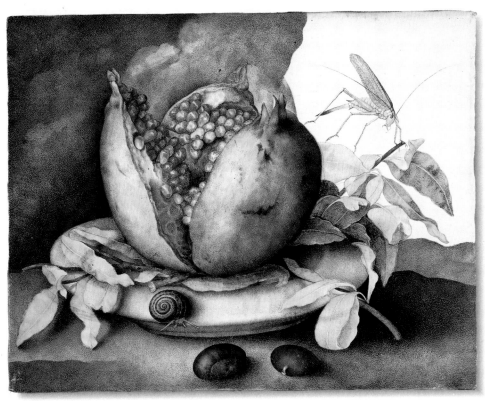

53

DAY AND NIGHT

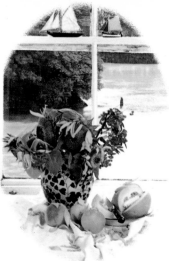

THE GREAT MAJORITY OF STILL LIFES are painted in an indoor setting simply because this is the most practical and comfortable circumstance for the artist. Apart from the ease of setting up the painting, working indoors allows greater control over the quality of light. For example, artificial light can be used to provide a steady light source or to create dramatic lighting effects. Natural light is unpredictable – a day can be bright and sunny one moment and then suddenly overcast, and all the colors change. Light from a window can make interesting shadow patterns, but remember that they will not remain the same for very long, so you will either need to make a sketch to remind you of how they fall or work very quickly. Changes in the quality of light affect the appearance, form, and tone of a still life (*see also* pp.38-39) – as you can see from the daytime and nighttime studies of the same window scene.

A window arrangement viewed by day.

1 ◀ Sketch the forms of the sunflowers, melon, and peaches with a light yellow wash. Paint in the petals of the sunflowers in Indian Yellow with Chrome Yellow, applying fluid brushstrokes with a flat brush. Mix Cerulean Blue and Yellow Ochre for the sepals at the base of the petals. Paint in the peaches with a wash of Chrome Yellow and Vermilion, using the same technique. Steady your hand by using your little finger to create firm, controlled brushstrokes.

2 ▶ Wash in the sails of the sailboat in Cerulean Blue, using a half-inch wash brush. Paint in the rowan berries with Vermilion using a small brush. You can leave dots of white paper clear to form the highlights. Next, mix a deep wash of Chrome Yellow and Vermilion to paint in the dark centers of the sunflowers.

3 ▶ Mix a wash of Permanent Rose and Cerulean Blue and block in the shape of the vase. The paper's texture can be seen through this very light wash. To deepen the tone of the petals and centers of the sunflowers, paint an intense wash of Indian Yellow over the first pale yellow wash. Use a large brush to intensify the pale green of the small leaves using Emerald Green and Lemon Yellow Hue.

4 ◀ Mix Permanent Rose with French Ultramarine and paint in the gray-mauve tone of the white window frame, seen here in shadow. Use a very dilute wash of Cerulean Blue for the cool blues of the sails so that the clear light outside the window appears to shine through them. With a dilute mix of French Ultramarine and Cerulean Blue, start blocking in the shapes of the distant trees seen on the far shore of the riverbank using a large brush. You will work these up later.

5 ▲ Deepen the color of the sunflower centers using an intense wash of Chrome Yellow mixed with Vermilion. Overlay the rowan berries with Vermilion, applied with a small brush. When the sunlight becomes brighter, the tone of the composition changes and the mauve shadows in the foreground become stronger.

Main palette

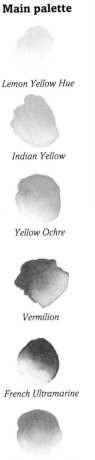

Lemon Yellow Hue

Indian Yellow

Yellow Ochre

Vermilion

French Ultramarine

Permanent Rose

6 ▶ Mix an intense wash of Magenta and French Ultramarine with a touch of Sap Green to paint in the knife lying next to the melon. Blend Permanent Rose with Cerulean Blue and deepen the color of the body of the vase, working with a medium brush. Now strengthen the knife by adding darker tones of purple. Apply a deep, dark green to accentuate the shadows among the leaves of the sunflowers. Add form to the melon by painting in deep golden tones using Indian Yellow. The painting relies to a large extent on complementary colors, with the purples and the yellows being mutually enhancing.

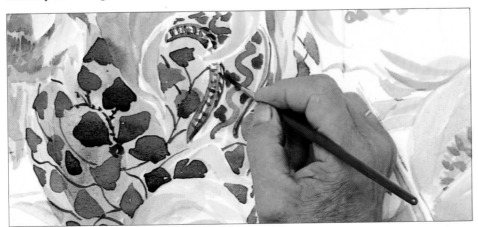

7 ◀ Paint in the patterns of the vase, using Ultramarine for the basic pattern and Permanent Rose for the fine details, applied with a small brush. Stand back and judge the progress of the painting: you can view the painting upside down to assess it as an abstract composition, or use a mirror to reverse the image (see p.29). Some elements of the painting may need to be brought forward; others can be made to recede. Adding "warm" colors such as reds and vermilions will make objects appear to advance; "cool" blues and purples will make them appear to recede.

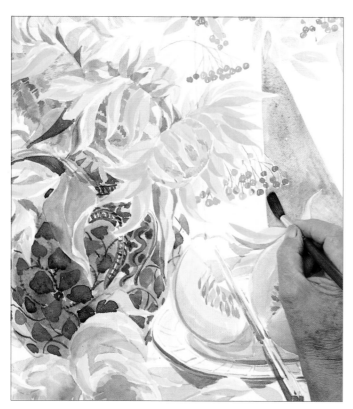

8 ◄ Overlay the Cerulean Blue of the sailboat's sail with an additional wash of the same color. By gradually building up color in this way, it is possible to retain the translucent quality of the watercolor paint. The paper has already been saturated with paint once and has dried. As a result, you may notice that when further washes of color are applied, pigment is absorbed more quickly but dries more slowly. Now deepen the color of the vase by overlaying a mauve made from Winsor Blue and Magenta. Enhancing the moody purples and mauves will bring the rich golden yellow of the sunflowers forward in space.

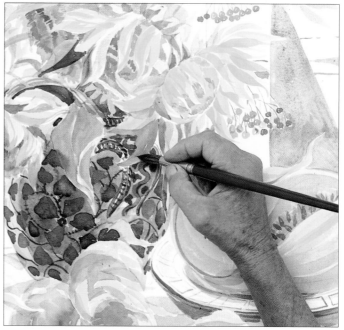

9 ▶ Strong sunshine casts deep shadows, so an even darker tone of yellow is needed for the sunflower petals. Apply an additional wash of Indian Yellow to the petals shaded by the main flowerhead. When painting the river, seen behind the sail, make a sweeping movement across the paper, but touch the brush down to the surface only intermittently to create a dappled effect.

10 ◄ Paint in the branches of the rowan in a dense blue-gray. The addition of these branches to the composition helps balance the painting. Add the leaves of the branches in Sap Green. Make simple, fluid strokes, turning the width of the flat brush sideways to its thinnest profile, to create their oval forms.

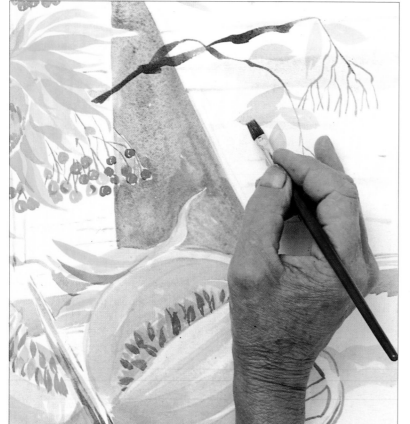

11 ▲ Add Chrome Yellow and Cadmium Orange stripes to the petals, making fluid strokes with a small brush. Darken the pattern of the vase and work your way around the painting building up the tones. Finally, using an almost dry brush, add dots of pure Cadmium Orange to the centers of the sunflowers.

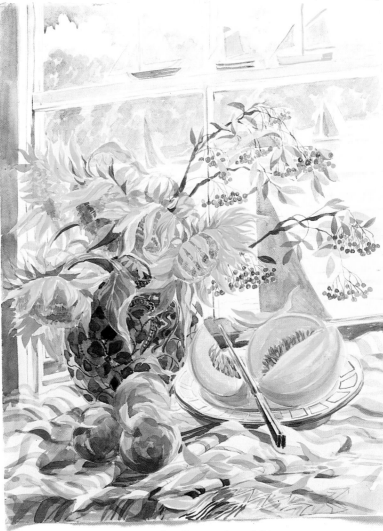

Sunflowers by day

In the daytime painting, bright sunlight shines through the window, backlighting the vase of flowers. Shining shapes appear in the negative space seen behind the composition, where light falls on the river or upon the distant shore. The peaches in the foreground and the vase appear as dark forms; their shadows come forward toward the viewer. The heart of the yellow melon is also in shadow. The geometric forms of the sails balance the rhythmic brushstrokes of the cloth, vase, and the petals. A knife, placed at a diagonal, leads our gaze into the central space of the painting.

Each sunflower petal has been created with a single deft stroke, using a flat wash brush.

The cool green leaves, or sepals, enhance the warm yellow and orange petals.

Elizabeth Jane Lloyd

Brilliant shades of sunlit yellow are expressed by Lemon, Chrome, and Indian Yellow pigments.

Sunflowers by night

Observed at night, the still life is lit from the front by artificial light and the mood of the painting has changed. Bright light falls onto the white cloth, and the vase, warming its blue and purple hues. Reflections of light on the window mask out all but the nearest sailboat on the river but pick out the toy boats perched on the window frame, which were almost invisible by day.

The rich color of the flower's center is deepened by the addition of Burnt Sienna.

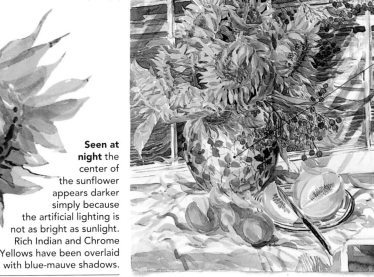

The shape of the crescent moon echoes the sections of melon and the fallen petals of the sunflowers.

The shiny ceramic surface of the vase reflects back the bright artificial light within the studio.

Seen at night the center of the sunflower appears darker simply because the artificial lighting is not as bright as sunlight. Rich Indian and Chrome Yellows have been overlaid with blue-mauve shadows.

Materials

No. 4 round

No. 10 round

No. 16 round

¼ in flat brush

57

ADVANCED TECHNIQUES I

AT ITS MOST BASIC, painting in watercolor involves applying pigment in varying degrees of dilution to the paper surface by means of a brush. This is just the beginning, however, because there is a vast range of techniques that can be used to produce interesting and unusual effects. You can, for example, enhance the strength of a color by adding gum arabic to it, either as a glaze over the top or diluted in with your paint mixture. You can scratch through the pigment in a technique known as sgraffito to reveal the white of the paper, as in the iris stem below. You can even use a toothbrush to spatter paint on to your paper surface to create random textured effects.

A long-stemmed blue iris

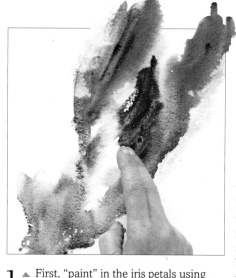

1 ▲ First, "paint" in the iris petals using clean water. Then, apply dilute mixes of violet and blue in the technique known as wet-in-wet; the colors will bleed into the paper. Before the paint dries, rub some gum arabic over the blue with your finger to make it appear more luminous.

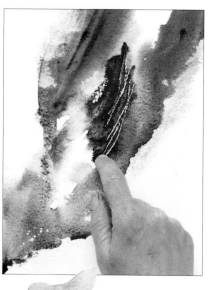

2 ▷ To add depth to the petals, use your fingernail to scrape lines through the dense layer of pigment and gum arabic. If you prefer, you can use the end of your brush or even a blunt knife to create highlights in this way. This sgraffito method exposes the white surface of the paper beneath and can be done while the pigment is still wet or after it has dried.

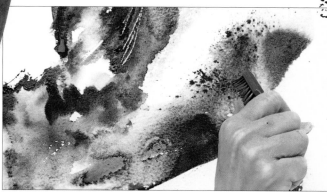

3 ▲ Load a toothbrush with lightly diluted paint and flick the paint onto the paper with your finger. This creates a diffused spattering of intense color against the base tone.

4 ▷ Paint the petal on the left with a deep mauve. You can lift off any excess pigment with a paper towel, or use the paper towel as a large brush to direct the flow of paint.

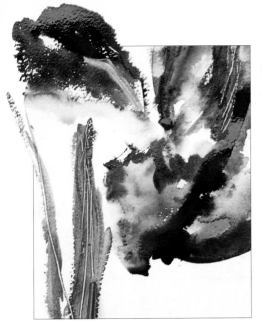

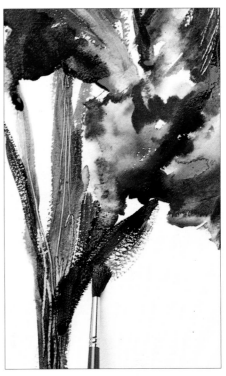

5 ◀ Paint in the stems and leaves of the iris using Sap Green with a little Lemon Yellow. To create the texture of the coarse stem of the iris, scratch into the pigment using the end of your brush.

6 ▲ Moisten a sponge with clean water and squeeze it almost dry. You can soften the intense color of the iris with the sponge while the paint is damp. Lift a little color from the paper, then turn the sponge around to use a clean area, and continue until you achieve a really pleasing effect.

7 ▲ Take up a little pure Sap Green pigment and paint in the leaves. These "dry" brushstrokes make textured marks and contrast well with soft, sponged effects.

Study of an iris
This sketch of an iris was executed quickly using a wide variety of brushstroke techniques to capture the immediacy of the artist's response to the flower. The painter is expressing her own personal vision of the iris, using every possible means to convey the contrasts and richness of the flower's color and form.

Dry brushstrokes give a clear impression of the slightly rough texture of the paper.

The dense blue spatterwork, applied with a toothbrush, softens the petal's form and gives it a more velvety appearance.

Lines scratched into the pigment for the stems and leaves of the iris suggest the fibrous nature of the plant.

Gum arabic creates a light but effective glaze, preserving the vitality of deep pigments.

Hilary Rosen

Materials

No. 12 round

Sponge

Gum arabic

Toothbrush

Paper towel

ADVANCED TECHNIQUES II

IT IS BEST TO USE HEAVY watercolor paper when experimenting with special effects since it will survive scratching, scraping, and repeated wetting. Thinner papers tend to disintegrate if you rework sections. Among the effects that you can achieve are lifting color off a page, making areas of your painting impermeable to paint so that the color cannot adhere to the paper, and scraping intricate patterns into the surface of the wet paint.

When trying to lift colors from the paper you will find that some pigments can be sponged off quite easily, while others cling to the paper fibers with determination. You can use a sponge, blotting paper, or even a paper towel to soak up color. Lifting colors allows you to alter your painting and possibly correct certain details. This section also includes resist techniques in which candle wax is rubbed over parts of the painting to protect highlights or to form interesting patterns and textures within the composition.

Changing tone
The dark green center can be lightened by simply wetting the area and then blotting the patch with a sponge or blotting paper.

1 ▷ "Paint" the tomato shape in with clean water. Use a large brush to apply a red wash to the wet paper to form the flesh. As the paper dries, overlay more intense washes of color. Paint the center of the tomato yellow and green. If the green looks too strong (*left*), you can still lift some of the color by wetting the area with a brush and then pressing a sponge or some paper towel to the paper. When you lift this off, some of the pigment will be removed.

2 ▲ Flood the area around the tomato with clean water so that the paper is quite wet, transferring the water to your paper with a large brush. Load a medium brush with deep blue pigment and wash in the foreground in front of the tomato with a sweeping, fluid movement. Angle your brush so you can make a controlled stroke around the tomato, retaining its clearly defined shape.

3 ▲ Take a section of plastic comb and run it over the blue pigment. Press down hard with the comb so that you create a series of deeply indented lines. Paint can be manipulated in this way to give the foreground an intriguingly textured appearance. If desired, you can take the comb over the paper more than once to create a crisscross effect.

MAKING COLORS BLEED

1 *Paint in the seeds of the pumpkin, picking out the dark corners hidden from the light. Wet the whole area of the pumpkin flesh with clean water before floating golden pigment over the wetted area.*

2 *To create the green skin, load a small brush with Sap Green and outline the pumpkin. Press the tip of your brush down and allow the green to bleed into the golden flesh but not into the dry area.*

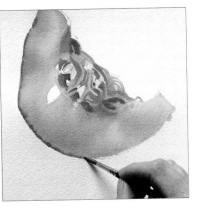

Materials

Blotting paper

Wax candle

No. 4 round

No. 10 round

1in wash brush

Synthetic sponge

Comb

Hair dryer

1 ◁ Draw in the outline of the watermelon slice. Wet the areas where highlights occur with clean water and then wash in a very pale blue. The blue will bleed into the moistened areas and become even paler. Use a hair dryer to dry the paper. Once it is completely dry, rub the end of a white candle over the blue highlights and over the corner of the slice. The waxed areas form a barrier that will resist any applications of paint.

2 ▷ Wet the melon again and then drag a wash of red over the image. Use a light green wash for the flesh close to the skin of the melon and a deep green for the skin itself, as described in the box feature above. Apply another wash of red pigment where the tone of the watermelon is deepest. Fold blotting paper so that it forms a firm straight edge, then press the folded edge into the pigment to lift threads of color.

Lifting out color and resist effects

It is important to get to know how the dampness of the paper will affect subsequent applications of paint, and to try out different dilutions of color in this wet-in-wet technique. In resist methods, a layer of wax applied over a light wash will preserve subtle tones against later layers of color. Always dry one area before starting work on an adjacent area so that colors do not bleed into each other – unless that happens to be the effect you want.

The dense earthy purple of the seeds is mixed from Indian Red and Prussian Blue. The red of the flesh must be dry before the seeds are painted in so that the deep purple does not bleed into the red.

These textured lines have been made by lifting red pigment with the crisp edge of a folded piece of blotting paper.

A layer of clear wax, applied using the end of a white candle, resists the first pale rose-red wash for the watermelon flesh.

61

SPECIAL EFFECTS

THE USE OF RESIST techniques and unusual surface patterns can add great interest to watercolor painting. In resist techniques you can protect the paper's plain surface or a pale wash against the subsequent layers of pigment by rubbing candle wax over it. Alternatively, scratching the surface of the paint with a comb or even the other end of the brush will create rich textural patterns that will vary slightly depending on whether the paint is wet or dry. Even such a simple device as working wet-in-wet makes a dynamic and natural effect in contrast to the crisp outlines and highlights defined with a fairly dry brush on dry paper. The combination of traditional and experimental watercolor methods can produce a bold yet controlled painting full of visual interest and technical complexity.

1 ▶ Arrange slices of pumpkin, tomato, and watermelon, then sketch them with a soft pencil. Use a pale wash of Prussian Blue to paint the melon seeds. With a large brush, wash in Cadmium Orange mixed with Permanent Rose for the flesh tones. As the paper dries, work with slightly less water on the brush and use a less dilute mixture to lay in deeper tones.

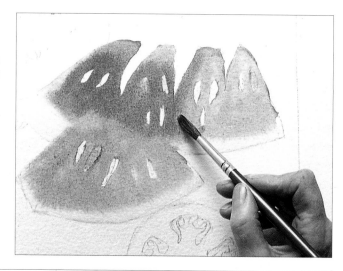

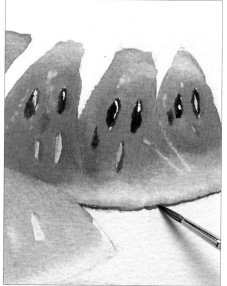

2 ▲ When the paint is completely dry, wet the outer flesh of the melon and lay in a wash of Naples Yellow and Sap Green. Trace a line of Sap Green for the skin with the tip of a small brush. Flatten the brush against the outer edge, and green will bleed into the yellowy-green wash but remain sharp along the outside of the melon.

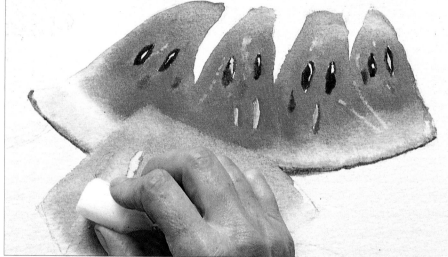

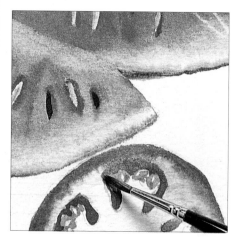

3 ▲ Rub a piece of white candle over an area of the melon in the foreground. Wax will resist further applications of paint and create shiny highlights in the finished painting. Overlay an intense wash of Permanent Rose and Orange Cadmium to deepen the flesh tones. Outline the darker seeds with Indian Red and Prussian Blue.

4 ▶ Wet the area of the outlined tomato with clean water. Mix Light Red, Indian Red, and Cadmium Orange and wash into the wetted paper. For the tomato, paint areas of intense red with a drier brush. Build up the colors using a richer blend of Indian Red, Light Red, and Cadmium Orange, and apply with a fairly wet brush.

5 ▶ Outline the pumpkin seeds with diluted Cadmium Orange. Wet the area of the pumpkin flesh with clean water, using a large brush. Then apply an intense wash in Cadmium Orange. Because the paper is wet, the darker orange will bleed into all the surrounding area. As the paper dries and pigment settles into it, work with a drier brush. Apply another wash to the pumpkin working on the dry surface to produce a bright, glassy wash.

6 ▲ Mix Winsor Green with a touch of Indian Red and lay in a flat wash with a wet brush. Re-wet the area and overlay a darker wash. Mix Winsor Green, Indian Red, and a little Prussian Blue and apply with a larger brush for the darkest corner.

7 ◀ Overlay the light green wash with a deeper green to create the ribs of the lotus leaves. While the paper is wet, use a section of comb to create distinct patterns for the veins of the leaves. Add in shadows, using Winsor Green, Indian Red, and a little Prussian Blue. The drier the brush, the greater the control you have over the pigment.

8 ▲ Mix Prussian Blue and Indian Red with a touch of Purple Lake. Wet the background with clean water and then drop in the wash using a large brush. Lift paint with blotting paper to soften the effect.

Materials

Wax candle

No. 4 round

No. 9 round

Comb

Rich textures
This painting relates to the texture and surface of the paper. Wax resist techniques and sgraffito, using the teeth of a comb, create strong rhythms. Flowing washes for the leaves and melon flesh contrast with the dark staccato strokes of the melon seeds and the leaf veins.

Areas waxed with the white candle resist the many overlaid washes of deep red pigment.

Combing deep green pigment creates a textured effect that suggests the delicate veins of the lotus leaves.

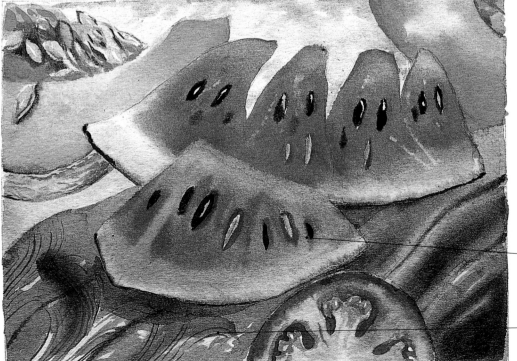

Josh Partridge

INTERPRETATIONS

ALTHOUGH THERE ARE MANY advantages to working from life with the objects directly before you, there may be times when you want to try a more experimental approach. You might want to paint from a photo or, a sketch, from memory, or perhaps even from your imagination. Here the artist has based his composition on two photos taken at different times of day. The dramatic contrast in color and light between the two images allows him greater freedom in his interpretation.

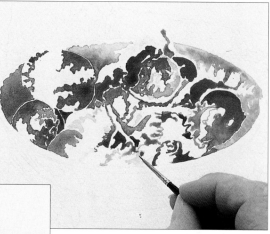

Picture reference
Daytime and nighttime photographs of scales, weights, and pigments seen in a Turkish felt dyer's workshop.

1 ▶ Trace the photo and enlarge the image on a photocopier to the desired size. Trace the image again onto tracing paper. Choose a pale red or yellow carbon paper then place it beneath your trace and over your chosen watercolor paper. You can transfer the outline to the paper by running over it with a ballpoint pen. Any delicate carbon paper marks will soon be masked by your brushstrokes.

2 ◀ Use a very small brush and a dense application of Brown Madder Alizarin to draw in the oak galls and create the interior of the right-hand scale pan. Carefully fill in details with a medium-sized brush. Then use a broad wash brush and very dilute pigment to block in the surrounding area.

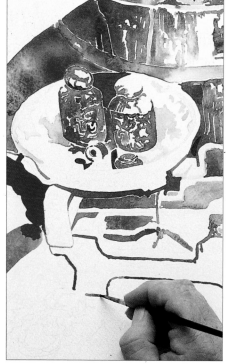

4 ▶ Fill in areas of deep pigment with the large wash brush, and gradually build up the foreground of the painting until the circle of the composition is complete. Then tint the area behind the scale pans with a dilute wash of Brown Madder Alizarin. If sections of the painting are very wet you can speed up the drying process by using a hair dryer. You may need to do this if you want to lay in more washes of color.

3 ▲ Turning to the left-hand pan, fill in details as before with a small brush, being careful to follow your guide lines. Outline the base of the scales with a strong mix of the red. The composition is taking shape and the background is gaining depth.

5 ▶ Load a medium brush with diluted pigment and hold it about 2in (5cm) above the surface of the paper. Using your finger, flick the hairs of the brush lightly in order to spatter the paint onto the tray. Repeat the process with a stronger solution of pigment over the other areas of the tray to create a textured effect.

6 ▲ Blend gum arabic into a dilute solution of Brown Madder Alizarin with your brush. When applied to the painting, the gum creates a light glaze in which particles of pigment are held in suspension.

7 ◀ Mix a deep wash of Indigo and apply it to the background area beyond the scale pan using a large wash brush. Where the glaze of pigment and gum arabic is thinner, the Indigo takes more strongly. Keep some blotting paper at hand and use it to remove stray drips.

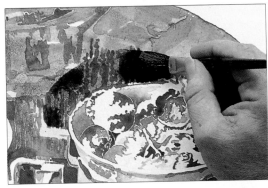

Brown Madder Alizarin resists the Indigo wash where it has been coated with gum arabic.

8 ▲ Use a dense Indigo wash for the shadows. Continue applying layers of wash to build up the tones. Finally, spatter some Indigo onto the tray to suggest its covering of various grains.

Materials

Brown Madder Alizarin

Indigo

No. 2 round

No. 4 round

No. 10 round

½ in wash brush

Fine ballpoint pen

Gum arabic

Strength through simplicity
The circular composition of this painting echoes the circular forms of the tray, the scale pans, the oak galls, and even the weights. The dark tones around the central image of the tray throw the objects into relief, and the limited use of color creates a powerful, eerie atmosphere.

Dramatic lighting echoes the nighttime photo.

Philip O'Reilly

GALLERY OF EFFECTS

THERE ARE NO ABSOLUTE rules to follow
in painting. The best guide is your
personal feelings or response, born of your
own experience. Use your imagination and
every means at your disposal to create your
own unique artistic statement. The intensity
of seeing makes the painting; the execution
follows instinctively. The more uninhibited
and individual the seeing, the freer the
painting will be. Some artists enjoy the tight
forms of a limited structure, others the open
spaces between the objects. Follow your
instincts and paint what you feel is a
beautiful whole. This gallery focuses on
aspects of structure, color, and composition
and how you can work with each to create
different effects. Experiment with gold leaf,
transparent glaze, wax, or even pastel!

Elizabeth Blackadder, RA, *Still Life with Irises*
*This painting combines disparate shapes and tones. The brushstrokes
themselves vary from delicate marks and patterns to broad linear strokes.
A yellow background, enhanced by gold leaf, throws the objects forward
so that they appear in isolation, like shapes on the surface of the moon.
Connections in tone and color create vibrations between the objects.*

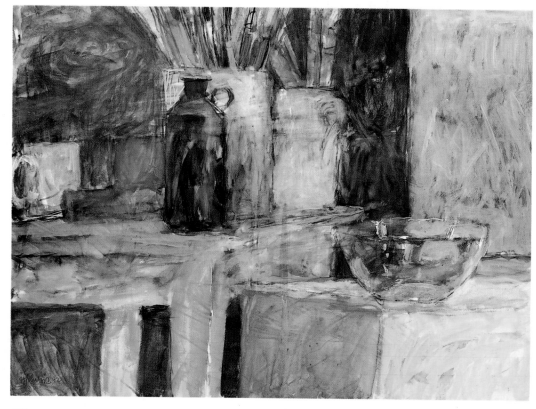

Hans Schwarz,
Studio Still Life
*The table, jars, and bowl form
a painterly unity developed
through varied brushstrokes.
Glowing yellows pervade the
rich darks and shine through
the cooler blues. The image
works well as a balanced
whole; each element interacts
to create an intense harmony.*

Light coming in from the right
of the painting focuses our
attention on the luminous
glass bowl. Highlights on its
rim are picked out by delicate
lines of Naples Yellow gouache.

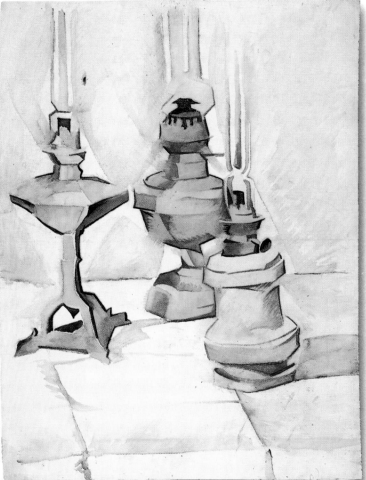

Juan Gris, *Three Lamps*, c.1910
In this sophisticated painting, spiral patterns are created by the oil lamps. The lamps on the cloth create vertical forms casting strong horizontal shadows, while the glass bulbs repeat the spiral forms of the lamps to make an architectural whole. The pure white cloth and the wall behind the lamps vary in tone subtly; the lamps stand forward boldly and are painted with effortless grace.

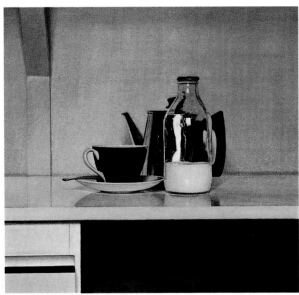

Jonathan Cramp, *Black Cup, Teapot, and Milk Bottle*
A cup and a milk bottle are placed in front of a starkly metallic teapot in this startlingly photorealistic painting. Three surfaces, three objects, move back within the picture plane. The red milk-bottle top focuses the eye just above the teapot, whose brilliant highlights are distorted by the clear glass. The artist studied his subjects at length in order to achieve such exquisite simplicity and clarity.

Mary Fedden, RA, *The White Cliffs of Dover*
This well-balanced composition of different patterns and shapes is placed according to the law of thirds, as defined by the cherries and the window frame. Fine black lines on the border of the yellow cloth contain the main forms. A dark triangle of shadow on the left and the white sweet corn lead the eye to the pitcher. The delicate gray pattern of the curtain is echoed by the pitcher and distant cliffs.

67

PRESENTING YOUR WORK

THE TYPE OF FRAME YOU CHOOSE for your painting is as important as the colors you used when you painted it – it can make or break an image. If you select a complementary frame, you will enhance the appearance of your work, whereas an inappropriate choice will have the reverse effect. Another benefit of framing is that the glass will protect the painting from dust and dirt, and help keep the colors true. Some painters like to frame their own paintings, while others prefer to rely on professional framers. Whichever option you choose, it is worth experimenting with a range of colored mats and frames to see which styles and tones are best suited to your work.

Defining your image

The way in which you decide to crop an image plays a vital part in the final presentation of your work. When you begin to mask off the edges of a painting, you immediately lose any slightly messy brushstrokes that border it. You can also crop the image even more to create a different view altogether.

Cardboard mats

The mat that surrounds the work provides a visual bridge linking the painting and the molding. The mats come in a vast range of colors, so you will need to decide whether to pick out a color from the painting or use a neutral one.

Picture glass is thin to minimize distortion.

Mats are made from acidfree paper that will not fade or yellow with age.

A paper lining shields work from the screw fixtures on the back.

Hardboard backing keeps the frame rigid.

Final assembly

When choosing a frame, try not to be daunted by all the choices open to you. Experiment with a range of ready-made moldings and some colored mats: the dark, medium brown, and pale limed wood of the moldings (*far left*) all echo colors in the work itself. The pale gray mat (*above*) brings this painting forward quite naturally, because it picks up the brightest highlights in the composition. Rose pink (*above*) is too strong for the earthy coloring of the image, so neutral cream proves to be the best choice.

Frame moldings

A huge variety of frames is available, from simple wooden ones to carved or gilded frames. Consider the color and width of each frame seen in relation to the mat, and the effect it has on the painting.

The pale cream mat picks up the painting's highlights and relates well to the pale bleached-blond fragments of driftwood.

The soft coral red of the inner mat defines the painting to great effect and echoes the coral color of the large shell.

The classic molding of the mahogany brown frame complements the warm earth colors of the painting and makes a strong contrast with the cream mat.

Sympathetic coloring

Here, the frame, mat, and inner, recessed mat have all taken their colors from the painting itself; the result is a harmonious whole. The cream-colored outer mat has been made deeper at the bottom of the painting in the traditional manner, so that the eye is drawn upward to focus on the image itself. Compare this treatment with that given to the dramatic interpretative painting at the bottom of the page, whose very simple mat is the same width all around the image, a style chosen in accordance with contemporary taste and in keeping with the arresting image.

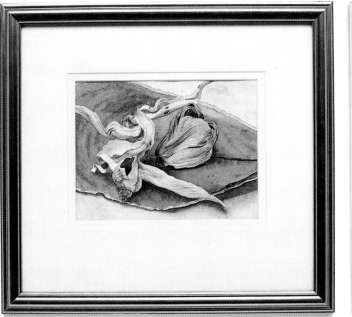

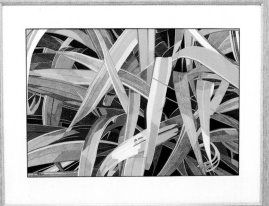

Good as gold

Gold frame and cream recessed mats are a conservative choice, which suits many "traditional" watercolors. The mat is deeper at the bottom, again a traditional feature. However, this approach might not suit a dynamic painting such as the study of striped leaves on the right.

A modern approach

This bold semi-abstract work is full of color and interest. It is well complemented by a plain, simple wooden frame and an off-white mat that allow this striking painting to make its statement unchallenged by superfluous decoration.

Double cream

This extravagantly wide wooden frame (*above*), combined with a cream mat, conveys a feeling of opulence despite its simplicity. The wood of the frame has a lustrous, pearly quality that harmonizes elegantly with the bone white driftwood seen in the painting itself.

GLOSSARY

ABSORBENCY The degree to which the paper absorbs the paint, often due to the amount of surface sizing.

ACID-FREE PAPER Paper with a neutral pH that will not darken excessively with age (unlike acidic bleached wood pulp).

ADVANCING COLOR The perception of a color, usually a warm (orange/red) color, as being close to the viewer.

ARTISTS' QUALITY WATERCOLOR PAINTS The best quality paints, with high pigment loading and strong colors.

BLEEDING The tendency of some organic pigments to migrate through a superimposed layer of paint.

BLOCKING IN Laying in a broad area of color.

BODY COLOR *see* Gouache.

BROKEN COLOR An effect created by dragging a brush over heavily textured paper so that the pigment sinks into the troughs and does not completely cover the raised tooth of the paper.

CHARCOAL Carbonized wood made by charring willow, vine, or other twigs in airtight containers. Charcoal is one of the oldest drawing materials.

COMPOSITION The arrangement of subjects on the paper. Ideally these are placed in a harmonious relationship with one another to create a sense of balance. Different artists may place the same elements of a still life very differently, as illustrated by *Seashore Visions I* and *II* (*see* pp.32-35).

COOL COLOR A color such as blue is generally considered to be cool. Distant objects appear to be blue, so cool colors are said to recede.

CROSSHATCHING Parallel marks overlaid roughly at right angles to another set of parallel marks.

DRY BRUSH TECHNIQUE A method of painting in which paint of a dry or stiff consistency is dragged across the surface of the ridges of paper to create a broken color effect.

EARTH COLORS These are naturally occurring iron oxide pigments, i.e. ochres, siennas, and umbers.

EASEL A frame for holding a painting while the artist works on it. A good easel allows the painting to be held securely in any position from horizontal to vertical.

ERASER A tool for removing pencil and other marks. In the past, artists used rolled bits of bread or feathers. More recently, artists have used standard rubber erasers, soft kneaded erasers, or artgum erasers, although the new plastic erasers are extremely clean and versatile.

FLAT WASH An application of an even and uniform area of tone and color.

FOCAL POINT In a painting, the main area of visual interest.

FUGITIVE Colors that are not lightfast and fade over a period of time.

GLAZE Primarily an oil painting term, but used in watercolor to describe an overall wash in a single color. This has the effect of unifying the appearance of various colors in a painting. Gum arabic (*see below*), sometimes used to glaze darker watercolor pigments, adds luster and interest to a painting.

GOUACHE A type of watercolor paint that is characterized by its opacity. This medium is also known as body color.

GRADED WASH A wash that is applied to paper by a process of gradually diluting or thickening the paint as the wash is applied, so that the tone in the wash runs smoothly from light to dark or dark to light.

GRAIN The degree of texture on the surface of watercolor paper.

GRANULATION The mottled effect made by heavy coarse pigments as they settle into the hollows of the paper.

GUM ARABIC Gum collected from the African acacia tree that is used as a binder in the manufacture of watercolor paints. Kordofan gum arabic, which takes its name from the region in Sudan from which it comes, is the main type used to bind pigments nowadays. It is sometimes mixed with pigments to impart added luster, or overlaid as a glaze.

HATCHING Making tonal gradations by shading with thin parallel marks.

HIGHLIGHT The lightest tone in a painting. In transparent watercolor techniques on white paper, highlights are represented by the white of the paper ground. In opaque or gouache techniques, highlights are represented with opaque white gouache.

HP OR HOT-PRESSED PAPER Paper with a very smooth surface.

HUE This term describes the actual color of an object or substance as it would appear in the spectrum.

LAYING IN The initial painting stage when colors are applied as broad areas of flat color, also known as blocking in.

Seashell

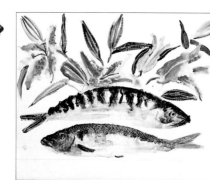

Painting enhanced with gum arabic

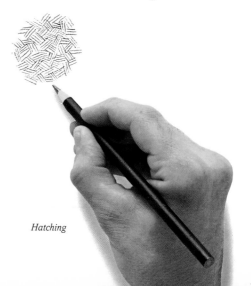

Hatching

LIFTING OUT Modifying color or creating highlights by taking color off the paper using a brush, blotting paper. or a sponge.

LOCAL COLOR The intrinsic color of an object as seen in an even and diffused light.

MASKING OUT The technique of using masking fluid or other materials to protect areas of the watercolor paper while adding washes. With masking fluid, the solution is allowed to dry, paint is applied over it, and, once that has dried, the masking fluid is gently peeled off.

NEGATIVE SPACES The shapes between objects, which can become as important as the objects themselves. Colors around the space occupied by the object become the outline of the negative shape or space.

NOT OR COLD-PRESSED PAPER Paper with a fine grain or semi-rough surface.

OAK GALLS Oak galls are formed by parasitic insects living off oak trees. They tend to appear in autumn. Dense black ink is made by crushing and boiling oak apples.

OPAQUE COLOR see Gouache.

PALETTE A shallow container usually made from porcelain or plastic with separate wells for mixing colors. The term also applies to the selection of colors habitually used by an artist in his or her work.

PRIMARY COLOR The three colors of red, blue, and yellow in painting that cannot be produced by mixing other colors and which, in different combinations, form the basis of all the other colors.

RECEDING COLOR The perception of a color, usually a cool-blue or green, as being distant from the viewer.

ROUGH OR COLD-PRESSED Paper with a rough surface or texture.

SABLE The tail hair of sables is used to make the best quality watercolor brushes.

SCRATCHING OUT see Sgraffito.

SECONDARY COLORS Colors derived from two primaries, i.e. green, orange, and violet.

SGRAFFITO A technique, usually involving a scalpel or sharp knife, in which dried paint is scraped off the painted surface.

SHADING Usually refers to the way areas of shadow are represented in a drawing; invariably linked with tone.

SIZING OR SIZE A material such as rabbit glue or gelatin applied to the surface of the paper to reduce its absorbency.

SPATTERING A method of flicking paint off the stiff hairs of a brush or toothbrush to create a random pattern of paint dots.

SPONGING OUT The technique of soaking up paint with a brush, sponge, or paper towel so that areas of pigment are lightened or removed from the paper. This method can be used to rectify mistakes.

SURFACE The texture of the paper. In Western papers – as opposed to Oriental – the three standard grades of surface are Rough, semi-rough (Cold-pressed or NOT), and smooth (Hot-pressed or HP).

TINTED PAPER Paper with a slight color. Oatmeal, pale blue, and gray are popular.

TINTING STRENGTH The strength of a particular color or pigment.

TONE The degree of light reflected from a surface.

TRANSPARENT PAINTING Using traditional transparent watercolors and relying for effect on the whiteness of the ground or on the various tones of underpainting.

UNDERPAINTING Preliminary paint layer or wash over which other colors are applied.

VIEWFINDER Two L-shaped pieces of cardboard that form a framing device. This is usually held at arm's length so that the scene to be drawn can be seen through it.

WARM COLORS Colors such as orange or red are generally considered warm. Warm colors like these appear to advance, while cool colors appear to recede.

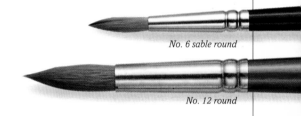
No. 6 sable round

No. 12 round

WASH A layer of color, generally uniform in tone, applied evenly across the paper with a large round or flat wash brush.

WAX RESIST Using wax to make patterns and shapes on the surface of the paper. Rub a wax candle over those parts of the paper that are to be protected from paint.

WEIGHT Watercolor paper is measured in lbs (pounds per ream) or gsm (grams per square meter). It comes in a large range of weights, although the standard machine-made ones are 90 lb (190 gsm), 140 lb (300 gsm), 260 lb (356 gsm), and 300 lb (638 gsm). The heavier papers, 260lb and over, generally do not need stretching.

WET-IN-WET A process of adding paint onto a wet layer of paint already applied to the surface of the paper. Merging color in this way is a simple and effective way of mixing colors subtly.

A NOTE ON BRUSHES

The brush sizes given here refer to Winsor & Newton brushes. They may vary slightly from those of other manufacturers. In the step-by-step pages, the terms small, medium, and large are used to denote a range of brushes that may be used.

A NOTE ON PAPERS

The surfaces of papers – Rough, Hot-pressed, and NOT (semi-rough), vary noticeably from one manufacturer to another, so it is worth looking at several before deciding which to buy.

Seashore Vision I, framed

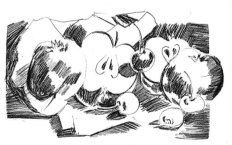
Pencil study

INDEX

ACKNOWLEDGMENTS

Author's acknowledgments

Elizabeth Jane Lloyd would like to thank Mary Fedden, RA, for casting a critical eye over the book; the Royal Academy for its valuable assistance; Emma Pearce at Winsor & Newton Ltd. for her expert advice; and the many artists who agreed to allow their fine paintings to enrich the book. Special thanks go to everyone at Dorling Kindersley, but particularly to my creative and understanding editor, Jane Mason; to Emma Foa, for setting up the project; to Stefan Morris, for his dedication to the graphic design of the book; to Margaret Chang, for her editorial assistance and research; and to all the DK photographers for their cheerful support.

Picture Credits

Key: t=top, b=bottom, c=centre, l=left, r=right,

Endpapers: Jane Gifford; p2: Martin Taylor; p3: Sarah Holliday; p4: Philip O'Reilly; p6: t Dürer, Graphische Sammlung Albertina, Vienna; b Garzoni, Galleria Palatina, Florence/Scala Insтито Fotografico Editoriale; p7: t Turner, Tate Gallery, London; c Cézanne, Tate Gallery, London/ Visual Arts Library; b Wyeth, Private Collection/Visual Arts Library; p8: b Turner, Tate Gallery, London; p10: t Margaret Stanley; p11: t Sharon Finmark; b Elizabeth Jane Lloyd; p12: t Hilary Rosen; c Sharon Finmark; b Elizabeth Jane Lloyd; p13: t Sharon Finmark; b Elizabeth Jane Lloyd; p14/15: tc Hough and b Brabazon, Chris Beetles Ltd; p15: t Paul Newland; c Nolde, © Stiftung Seebüll ada und Emil Nolde; b Geraldine Girvan, Chris Beetles Ltd; p18: tl The Limbourgs, Musée Conde, Chantilly/Giraudon; p23: all Elizabeth Jane Lloyd; p24: t Tsubaki Chinzan, Bridgeman Art Library; b Elizabeth Jane Lloyd; p25: t Raoul Dufy, Private Collection/Visual Arts Library; c © James Tan; b John Yardley; p26/27: Paul Newland; p28: tl Annie Williams; p29: t Paul Newland;

p36: t Picasso, Reproduced by courtesy of the Trustees, The National Gallery, London; b Brabazon, Chris Beetles Ltd; p37: t Rita Smith; c Claire Dalby, courtesy of Mrs. Johnston; p46: t Philip O'Reilly; b Mackintosh, Glasgow Museums: Art Gallery and Museum, Kelvingrove; p47: lc June Berry; tr Paula Velarde; b Catherine Bell; p52/53: c Christa Gaa courtesy of Ken Howard, RA/New Grafton Gallery; p52: l Lorraine Platt; b Martin Taylor; Chris Beetles Ltd; p53: c Sue Sareen; b Garzoni, Galleria Palatina, Florence/ Scala Insтito Fotografico Editoriale; p66: t Elizabeth Blackadder, RA, Royal Academy of Arts Library; p67: t Gris, Kunstmuseum Bern; c Jonathan Cramp; b Mary Fedden, RA, Royal Academy of Arts Library.

Dorling Kindersley would like to thank: Art for Sale, London; Blue Jay Frames, Possingworth Craft Workshops, Blackboys, East Sussex for its excellent craftmanship; Putnams Paper Suppliers, London for supplying samples; and the Royal Watercolor Society for advice and support. And heartfelt thanks go to our author Elizabeth Jane Lloyd for taking all of us into the fourth dimension of seeing.